COLLAGE COUTURE

TECHNIQUES for CREATING Fashionable Art

Julie Nutting

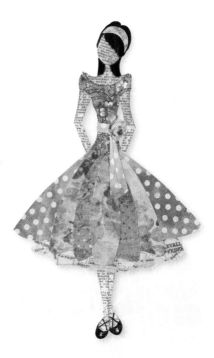

NORTH LIGHT BOOKS

CINCINNATI, OHIO

15 14 13 12 5 4

DISTRIBUTED IN CANADA BY FRASER DIRECT
100 Armstrong Avenue
Georgetown, ON, Canada L7G 5S4
Tel: (905) 877-4411

DISTRIBUTED IN THE U.K. AND EUROPE BY F+W MEDIA INTERNATIONAL
Brunel House, Newton Abbot, Devon, TQ12 4PU, England
Tel: (+44) 1626 323200, Fax: (+44) 1626 323319
Email: postmaster@davidandcharles.co.uk

DISTRIBUTED IN AUSTRALIA BY CAPRICORN LINK
P.O. Box 704, S. Windsor NSW, 2756 Australia
Tel: (02) 4577-3555

Library of Congress Cataloging in Publication Data
Nutting, Julie, 1957-
 Collage Couture : Techniques for Creating Fashionable Art / Julie Nutting.
-- First
 paper cm
 Includes index.
 ISBN-13: 978-1-4403-0831-4 (pbk. : alk. paper)
 ISBN-10: 1-4403-0831-4 (pbk. : alk. paper)
 1. Collage. I. Title.
 TT910.N88 2011
 702.81'2--dc22
 2010041979

media
www.fwmedia.com

Editor: Rachel Scheller
Designer: Kelly O'Dell
Production Coordinator: Greg Nock
Photographers: Christine Polomsky, Ric Deliantoni
Stylist: Jan Nickum

An altered version of the patterned paper "Full of Flowers" from My Mind's Eye appears in the design of this book. www.mymindseye.com

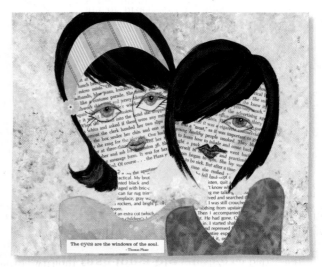

The eyes are the windows of the soul.
-Thomas Phaer

About the Author

Julie Nutting has been creating for as long as she can remember. She started drawing fashion figures when she was about nine years old. She grew up in the era of the first really fabulous fashion doll clothes, a time when doll clothes were exact replicas of Dior coats and Balenciaga gowns. When she couldn't have the clothes she wanted for her dolls, she simply made them from her mom's pretty pastel hankies or fabric scraps headed for the trash bin. This led to a lifelong love of fashion illustration, design and sewing.

Julie lives in sunny California with her husband and two kids. They all have an appetite for travel and gardening. When she's not busy creating, you can find her outside playing in the dirt, growing an abundance of vegetables, herbs and flowers year-round.

Metric Conversion Chart

To convert	to	multiply by
Inches	Centimeters	2.54
Centimeters	Inches	0.4
Feet	Centimeters	30.5
Centimeters	Feet	0.03
Yards	Meters	0.9
Meters	Yards	1.1

Dedication

To John, who made sacrifices so I could follow my dream, and to Sean and Lorrena, who encouraged me to chase it during the bleakest of times.

Acknowledgments

I have a deep gratitude to all who have encouraged me to believe I was given a gift and that it was meant to be shared. I believe the toughest part of an artist's journey is believing in oneself. These are the people who have made that part of the journey a bit easier for me:

My mother, who always made sure I had art supplies growing up, even when I knew the money was low.

My sister, who takes such good care of my mom in her later years.

My aunt Virginia, who, from very early on, knew I was an artist and has always encouraged me to believe that is exactly what I am supposed to be.

My absolutely wonderful friend Denice, who showed me there was something bigger than myself and set me on the right path to find it.

My good friend Tricia, who has the most impeccable taste and insisted that I was talented when I did not think so.

Michele, who actually purchased my art and was one of my first fans. She's a lawyer and drives a Porsche, which really has nothing to do with anything except that it seems to validate the fact that perhaps I am gifted . . . a little.

Rachel, my editor, who made this process so easy. Much to my relief, she was not the snooty editor that so many movies portray!

Christine, who, as a photographer, really knows how to put a person at ease. She is kind, nurturing and completely selfless when it comes to her work.

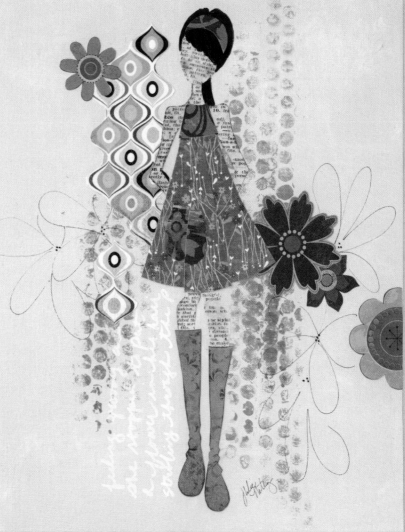

Kelly, my designer, who took this book and made it into a visual masterpiece.

Tonia, who took my proposal and helped me turn it into something better.

My husband, John, who has never really understood my creativity, but pretends to.

My son Sean and daughter Lorrena, who thought the best thing that ever happened to me was losing my job in the middle of this miserable economy because it forced me to follow my dream of being an artist.

Losing a job in the only field I've ever known has been a difficult challenge. It made me question everything I've done. After many, many prayers, He answered them in the form of many new opportunities, one being this book. For that, I am forever grateful. Life is too short to waste your God-given gifts, and I thank Him every day for mine.

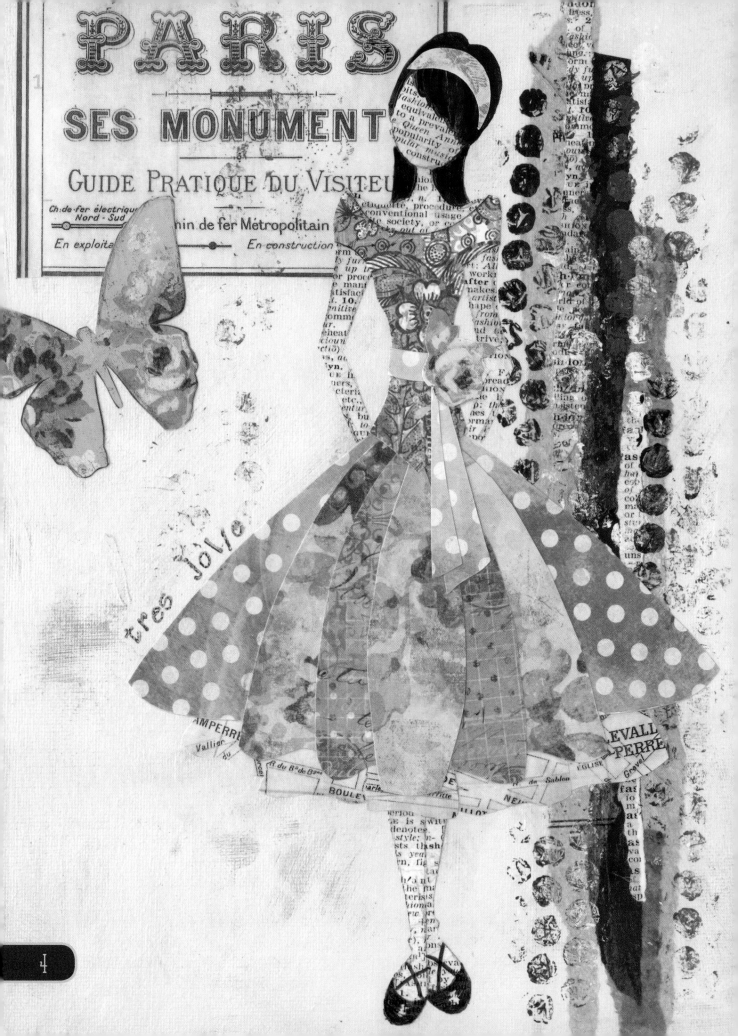

CONTENTS

INTRODUCTION 6

CHAPTER 1
Techniques 8

Sketching a Fashion Figure 10
Facial Features and Hair 16
Sketching Clothing 20
Folds and Ruffles 26
Putting the Figure Together 28
Background Techniques 29

CHAPTER 2
Fashion on Canvas 32

Vogue 34
Chocolate Strawberries 38
How Do I Look? 42
Denim Girl 46
Postcard from Paris 50
Chopsticks 54
Newspaper Heiress 58
La Bamba 62

CHAPTER 3
Framed Fashion 66

Un Papillion 68
Feeding the Spirit 70
Moulin Rouge 74
Princess of Hearts 80
Parisian Inspiration 84
Aubergine Dream 88

CHAPTER 4
Fashionable Gifts 92

Dress It Up 94
Meet Veronique and Antoinette 96
Amelie Plays Dress-Up 98
Parisian Dreams 100
Japanese Garden 104
She's Just a Little Bit Shy 108
Happy Hour 112
What Shall I Wear? 118

RESOURCES 126
INDEX 127

Remember those carefree times as a child? If you were like me, you probably played with paper dolls or Barbies and dreamt of how glamorous your life would be as a grown-up. When my dolls were wearing their fancy Dioresque gowns, they never changed diapers, did the dishes or went to the market. My dolls' pretty little sports car with the 1960s turquoise interior never had to go in for an oil change! My perfect-looking dolls had the perfect lives, with perfect maids and nannies.

When we grow up, though, we realize that real life isn't like this. It happens to all of us at some point: as we perform necessary chores, we have days when we think we will never see glamour again. It is so important to reconnect with that little girl we left behind. When I make art, I can reenter that wonderful world of make-believe, dress-up and paper dolls that I found so enchanting as a child.

I fondly remember rainy days filled with hours of playing paper dolls and creating my own fashions for them. Yes, I loved the clothes that I carefully cut from the box, but I also loved to draw my own styles and color them with vibrant patterns. I remember feeling satisfaction in having created something to play with that did not come from a box.

This book will teach you how to create fabulous fashions and how to find your inner girly-girl. There are many projects to choose from: mixed-media art to hang on the walls, sweet art books to journal inside, and paper dolls to share with the special girl in your life. I use simple materials that are easy to find in any craft store. I love the process of hand-cutting a butterfly instead of using a die-cut machine. If I can't find the right stamp, I carve my own.

I also like to set the mood for my art time. It's important that my space makes me feel, well, pretty. Sometimes it means changing into my most comfy pink pj's and having coffee in the prettiest cup I can find. I like to have my most-used supplies at hand. My brushes and markers are in beautiful cups that find their way into my studio from flea markets. Family heirlooms don't hide behind cabinet doors in my house. Depression glass sits on my shelves, holding all sorts of goodies. Cotton swabs stand up straight in a crystal liqueur glass. Sponges and stamps settle into vintage bowls that belonged to my great-grandmother. Colorful vintage buttons sit in apothecary jars for all to see. Music is always playing, and it's even better when it's French!

I invite you into this world of mine. It's a place where you can leave the dishes alone and your worries behind. We will draw fabulous clothes. We will sketch ball gowns that you would probably never wear and ruffles that are way too girly but oh-so-beautiful to look at. We will draw whimsical faces and paint hair any color we want, as long as it's not gray! We will add glitter, shimmer and bling—yes, lots of bling. Grab your mixed-media tools and a cup of tea, and let's play!

Techniques

It's playtime!

Get comfy, grab a cup of tea and bring out your pencils and paintbrushes! Leave your inhibitions behind while we learn how to sketch fashion figures and create all sorts of fun background techniques in this chapter.

We will learn the basic proportions of figure drawing, and from there, I encourage you to develop a style that is yours alone. There are so many ways to incorporate your own ideas into your pieces. I love to use script paper for my figures' bodies. You may want to use old maps or menus. Maybe you don't want to use script paper at all. There are plenty of other options, such as using a background stamp on plain paper. You may want to have legs that are twice as long as the ones in my sketches or are just straight lines with hearts for the knees. As you learn these basic steps for drawing, let your imagination run wild!

My background techniques are easy to learn, and you may use as many or as few layers as you wish. We will use sponges, brayers and old gift cards, each technique creating its own unique look. We will not only stamp with traditional stamps, but also use more unusual items such as potatoes and Bubble Wrap. Think about what else you can use in your backgrounds. There is no limit to your imagination!

It Takes Lots of Practice!

Fashion sketching took me years of practice to master. I'm not a "natural," so I didn't just sit down and start sketching recognizable poses of the human body. It also took a lot of practice to develop my own style. I'm happy to say that I can now sit, have a pose in my mind and sketch it in a fairly quick manner. Anyone who looks at it will know the style is unmistakably mine.

Recently, I was asked to draw a reindeer. A reindeer?! I had no idea what a reindeer looked like, and I wasn't able to draw one out of the blue. I referred to the Internet to find an image of a reindeer, and I felt uncomfortable as I started to draw him. I tweaked, erased and tweaked some more before he resembled a reindeer. I share this with you because I don't want you to be intimidated by drawing. It takes practice—lots of practice! As you learn, remember to be patient with yourself.

There's the Right Way, and There's the Quick Way

First, we will learn the right way. I took a basic drawing class in college, but I didn't have the time or patience to learn to draw the correct way. Design classes hit hard and heavy, and I learned to draw as most design students learn: quickly, using croquis. A croquis is simply a sketch of an undressed figure. Tracing paper is placed over the croquis to sketch the figure's outfit. After completing this chapter, you should have the knowledge to sketch your own set of croquis to complete the projects in this book. We will learn a very condensed version of drawing a figure the correct way. We will dissect what we're doing so we can understand the process.

Use these guidelines as a starting point for developing your own style. As artists, we don't always like doing things the right way. Once you learn the proportions I've provided, you can go crazy creating your very own signature approach. This is when legs and necks can become longer, heads can become smaller, and elbows and ankles can be exaggerated points. Lips can emerge into hearts, and eyelashes may extend to the middle of the cheek with swirls at the ends! You may want to draw primitive, chubby or stick-like figures. This is where the fun begins!

Drawing the Grid

Begin by drawing and numbering thirteen horizontal lines across your paper in 1" (2.5cm) intervals, starting with zero. The head is 1" (2.5cm) long, and the figure will be the equivalent of twelve heads. Realistically, the human figure would be seven heads tall. In fashion sketching, the body is always elongated to show off the clothing. Why? Because it's all about the clothes! It's important to note here that another artist might use fifteen lines and draw very long legs. I happen to like the twelve-head rule, although I've been known to change it up sometimes. Label your horizontal lines according to Figure A. Sketch in your figure, again referring to Figure A. This is a front-view figure, meaning both sides are symmetrical. Figure B shows how a figure will look with clothes. You now have your first figure!

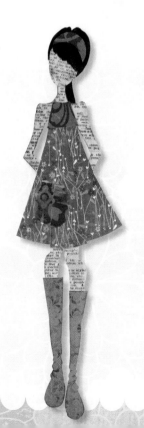

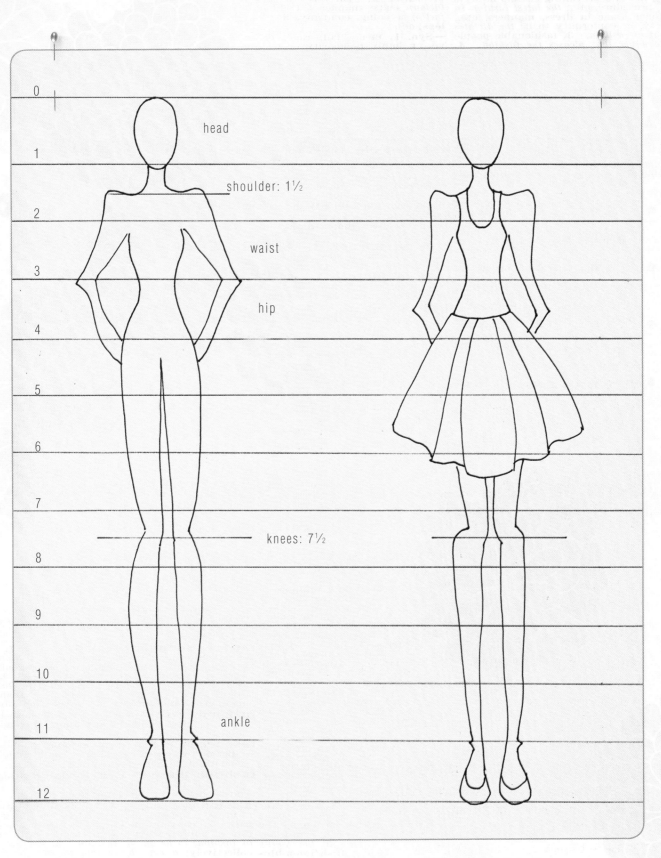

0	
	head
1	
	shoulder: 1½
2	
	waist
3	
	hip
4	
5	
6	
7	
	knees: 7½
8	
9	
10	
11	ankle
12	

FIGURE A FIGURE B

Three-Quarter-View Figure

In this sketch, the body turns slightly, with the center front rotated to the side. One side of the body shows more than the other. Once again, draw and label thirteen horizontal lines. Refer to Figure C as you sketch in your figure. Note that these first poses are just that: poses. Next, we will add a little movement to our girls.

Movement and Attitude

In the previous figures, the shoulder, bust, waist and hip lines were straight across, parallel to the floor. This creates a figure that appears to be still. Angling these lines creates movement and attitude. Notice in Figure D how the figure's shoulders go up and her left hip goes down. These opposite lines give her a bit of attitude, don't you think? When you practice drawing this one, try angling your lines even more drastically and see what you come up with.

The Balancing Act: Don't Tip Over!

The red vertical lines in Figures D and E indicate the balance line. This line helps the figure stand upright. This line usually falls close to the supporting leg and ends up somewhere near the ankle. The other leg does not appear to hold her weight at all. It is so important to note this line; otherwise your girl will appear a bit tipsy, and we don't want anyone to think bad thoughts about her!

The dotted lines in Figures D and E represent the center front. This line has nothing to do with balance or leg positions. It's solely used to help you move her torso into a pose. It's also necessary to know where the center front is when designing her clothes.

The Quick Way!

Now that you understand proportions and movement, there is an easier way to do this. Fashion magazines and catalogs offer lots of poses to work from. Find a front figure pose that you would like to draw and place a sheet of tracing paper over it. Trace over the head, neck, arms, legs and anything that's not dressed. Draw the horizontal lines in where the shoulders, bust, waist and hips should go. Connect all the parts together until you're happy with your figure. *Voilà!* You have a fashion figure that's ready to dress within minutes!

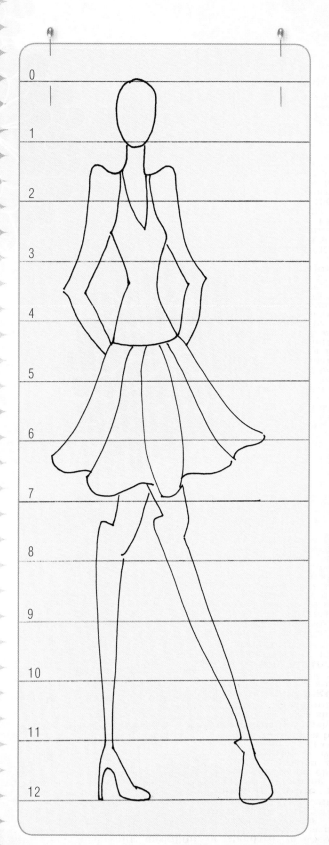

FIGURE C

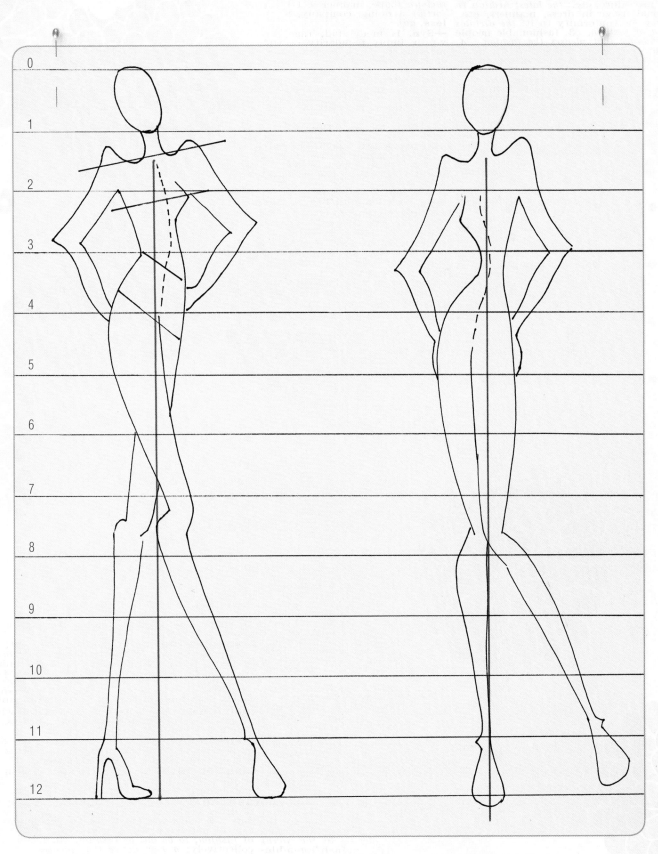

FIGURE D FIGURE E

13

For the Child in All of Us

I think my art lends itself well to children. I've had many requests to make pieces with kids instead of women. Refer to Figure F to see how the proportions are different for a child. She is, of course, shorter with no curves, but her head is also larger and rounder. You may want her torso and legs to be a bit wider, too.

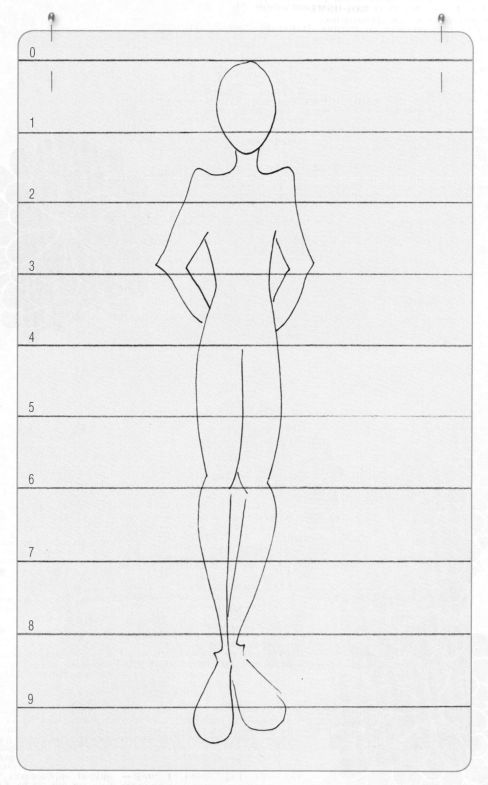

FIGURE F

14

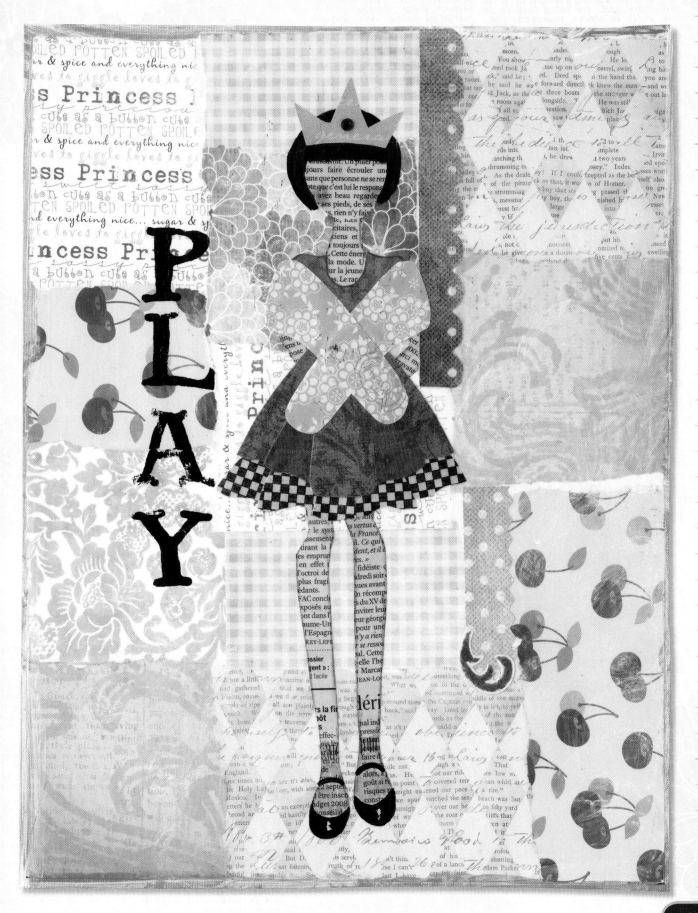

Let's Face It

Many moons ago, I worked for a fashion designer. She could not draw nice presentation sketches. One day she asked me if I knew any classmates who could draw well enough to do some presentation sketches for her. I very shyly told her that I could draw. She asked me to bring something in the next day to show to the sales team. Of course, I panicked. Could I really draw as well as I thought? I stayed up most of the night sketching out some cute kids in current fashion collections. When I showed them to her the next day, she said, "Very cute! But where are the faces?" I told her they didn't need faces; after all, it was all about the clothes! I was sweating it; I couldn't draw a decent face if I stayed up for a week straight. She bought it! I did her sketches for many years until she retired. She never knew that I couldn't draw a face!

I share this with you so you won't be afraid to draw a face. It really wasn't until about a year ago that I started drawing faces regularly. I learned to draw them by doodling and experimenting. My meeting notes from work always had girly-girl faces all over them!

The Perfect Set of Eyes

Let's start by practicing each part of the face, and then we will put it all together when we're finished. Referring to my sketches, draw some random eye shapes, drawing round eyes as well as narrow ones. Sketch in the iris and pupil. Cut out one eye.

Across another paper, draw two lines parallel to each other about 1" (2.5cm) apart, as in Figure G. Place the cut-out eye shape between the lines and trace around it. Turn it over and trace another eye ½" (1.5cm) to the right of the eye you just traced. You now have a perfect set of matched eyes. I use this method sometimes when I really want my eyes to match. Other times, I will draw them freehand because, after all, nobody has perfectly matched eyes! Of course, you can use my shortcut to achieve the perfect set of eyes: just draw one eye and cover the other with bangs. Works every time!

Pucker Up!

When I was learning to draw faces, lips and noses were always the hardest for me. This is where developing your own style comes in handy. I've provided various lip shapes for you to practice in Figure H, and I'm sure you'll probably come up with more of your own. I simply draw lines for my noses, making the lips and eyes the focal points.

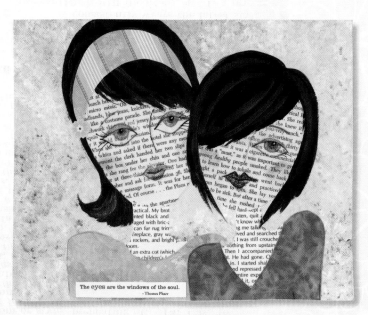

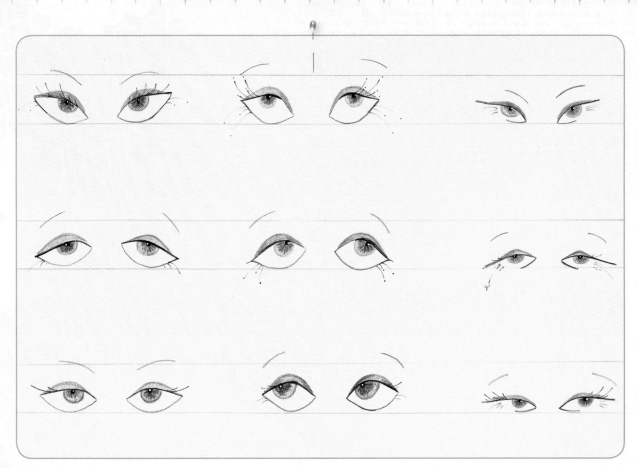

FIGURE G

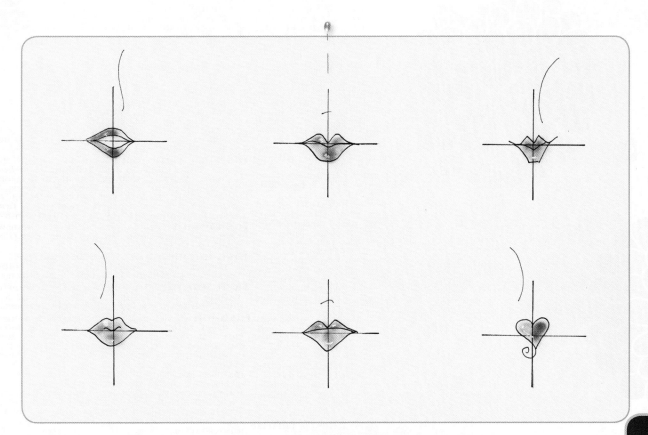

FIGURE H

Hair

Any girl knows that the hair is as much a part of the outfit as the clothing. For some reason, the girls in my pieces are mostly brunettes or redheads. Sorry, blondes, it's nothing against you, I promise!

When I was growing up, I wanted to be a hairstylist. I can't even blow-dry my own hair, but I love to paint hairstyles. You can go short and spiky, or long and curly, or anywhere in between. Hair is much easier to create than it may seem. I use a high-quality liquid acrylic paint for hair because the colors are richer than the cheaper brands, and it's important to me that the hair is true to color. Remember, we're not working with fine art, so don't let the prospect of painting scare you away.

For blond hair, I start with a mustard color, then use a burnt sienna over that and top it off with gold metallic highlights. For brown hair, I start with burnt sienna, then use raw umber and top it off with bronze highlights. For black hair, I simply use black with a light touch of bronze highlights. If I want a redhead, I follow the instructions for blond hair, increasing the amount of burnt sienna. I love using metallic highlights, but wouldn't it be fun to try hot pink or deep purple?

Last but not least, I like to finish a hairstyle with a headband, scarf or flowers to complete the look. Don't leave out hats! A big straw hat or a small pink pillbox would be quite fun!

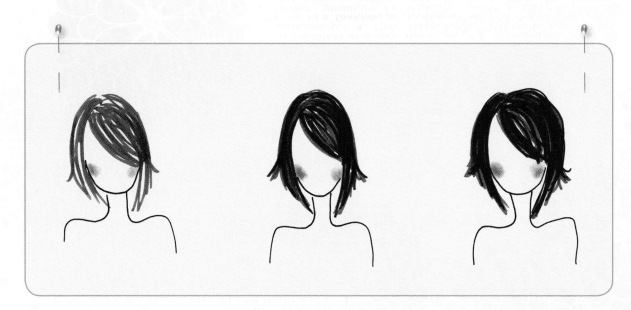

FIGURE I

Let's Put It All Together

Start by drawing an oval. It can be slender or more round; make it your own style. Draw a line down the center and a line across the center of the oval so you have a cross as in Figure J. The intersection is the center of the face. Draw another line above the horizontal line. The distance between the two can be whatever you want. This is how wide the eye will be. Now simply draw in the eyes, nose and lips using a light pencil. Outline the eye and eyeball with a black colored pencil and then color in the pupil. Choose an eye color and color in the iris. Use a white gel pen to dot the pupil with a highlight. Color in the eyelid with the desired color, just as if you were applying eyeshadow. Outline the outer corner of the eye and draw in lashes with a black fine-tip marker. Use the marker to outline the nose and lips, and then fill in the lips with the colored pencil of your choice. Use pink or red chalk to apply blush to the cheeks. *Voilà!* You now have a face!

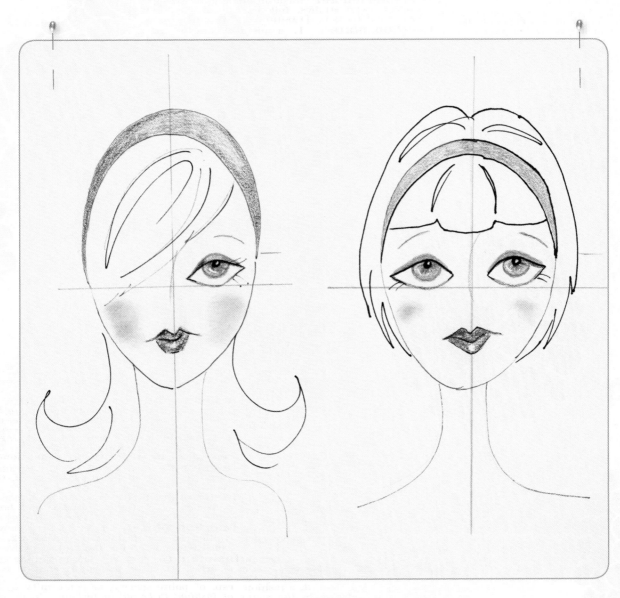

FIGURE J

19

SKETCHING CLOTHING

In this section, we will learn some basics about sketching clothes. We will also talk a bit about style, just to keep your creative juices flowing. This is your opportunity to play fashion designer!

Once I have my figure drawn, it's time to dress her. Most of my clothes have lots of folds. The more folds there are, the more varied patterns of paper you will get to use. Figures K and L are the basic silhouettes and necklines that I use. Of course, there are far more, and

I'm sure you will think of others when you sit down to draw. You will see that the waistline hits in different locations on the body. The folds of the skirt will fall from the waistline whether it's high, low or normal. Notice the sheath and the tent silhouettes don't have a waist. I added these to feed your imagination. The tent could be a cute retro look with contrasting giant pockets, and the sheath could be done in sections, which could be quite retro-chic.

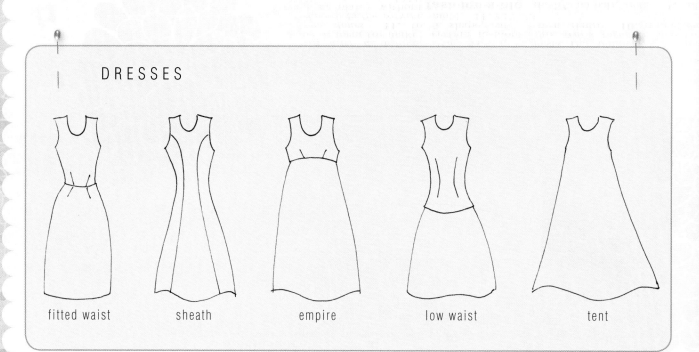

DRESSES

fitted waist sheath empire low waist tent

FIGURE K

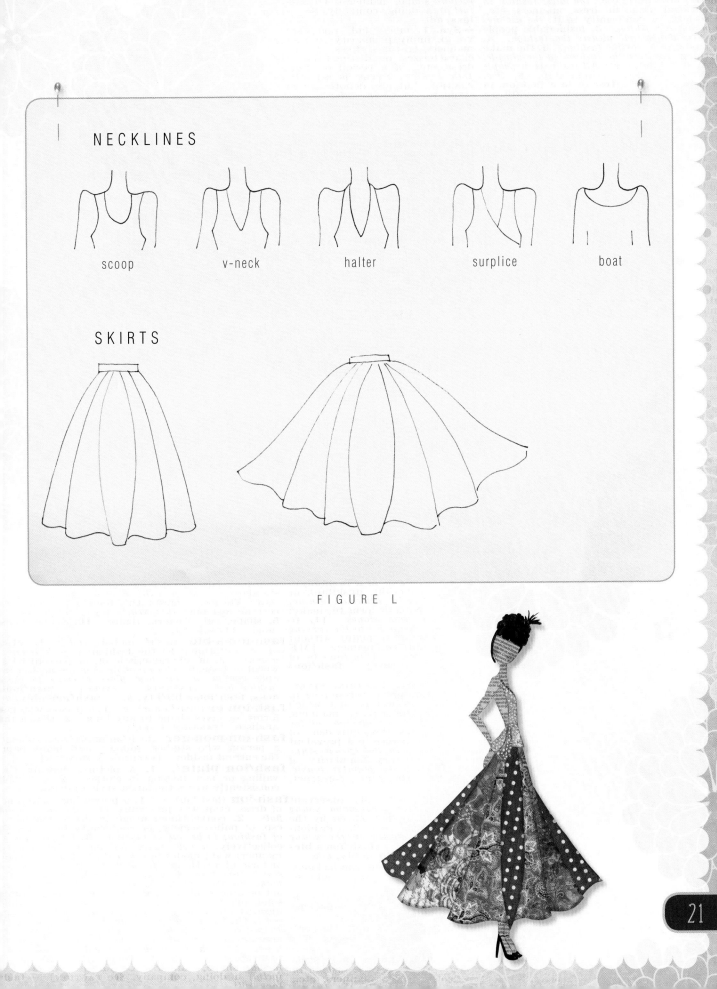

NECKLINES

scoop v-neck halter surplice boat

SKIRTS

FIGURE L

Decide on Style

Before starting any project, you must decide on style. It's just like when you start your day. Will you dress casual, retro, or maybe with a touch of glam? There are as many styles to choose from as there are ice-cream flavors. Sometimes a certain paper will inspire me; other times it might be a color palette. I will highlight a few of my favorite styles that I use day in and day out in my art. Within each of these is a haven of inspiration to get your creativity going in high gear.

Whatever your style . . . *have fun!*

GLAMOUR GIRL

Of course, glamour means lots of bling, more bling and perhaps a sprinkling of glitter thrown in. The gowns should be nothing short of spectacular. Small-waisted with full skirts, long and slinky, or short and sassy, it doesn't matter as long as there's plenty of drama! Leopard-print, zebra-print, tiaras, crowns or feathers can add the perfect finishing touch. Try stamping a chandelier in the background for some added glam. The Eiffel Tower and some French script would be right at home here.

A BIT OF ROMANCE

Collage wouldn't be collage without the romantic vintage look, would it? Shabby vintage florals are the key to this look. Cabbage roses paired with stripes are the perfect match here. Think soft pastels and worn, torn edges. The skirts should be full with maybe a few ruffles peeking out. Personally, I like lots of ruffles. Just when I think I can't add another ruffle, I add it! A damask stamped pattern using Distress Ink would make a nice background. Butterfly die cuts or old perfume labels could be added for the perfect shabby-chic look.

EVERYTHING'S GROOVY

Groovy it is! Bold geometrics, mod flowers, zigzags and checkerboards will dominate the retro look. Think miniskirts, fishnets and crazy hot colors. The brighter, the funkier, the better. Short hair, long lashes and pouty lips are so much fun. Stamp some daisies into your background with peace signs in the centers! Wouldn't a street map of London look great mixed into the background?

Let's Start Drawing

You should now have at least two croquis to dress: the full view and the three-quarter view. Outline them with a black marker. Place a piece of tracing paper over one of the croquis and draw your dress. I always start at the neckline and work my way down. Practice drawing the folds of the skirt. You may sketch as many as you like, but I usually have two folds on either side of the center front fold. These can be tight or big and flowing. Just keep practicing different sizes and lengths. Once you're happy with the dress, sketch in the rest of the body. Remember, you're just drawing an outline, nothing fancy. You may have noticed I did not give instructions for sleeves or collars. You certainly may use these elements in your design; however, the paper cutting can get very tiny, so I tend to keep the lines as simple as possible.

You now have your first design. Set it aside, and we will learn how to assemble it on page 28.

Setting the Mood

There's nothing more inspiring than a movie with great costumes! Rent *Marie Antoinette* or *Coco Chanel* and focus on the costumes as you watch. Keep a pretty sketchbook nearby to jot down ideas.

Colors and Patterns

Color . . . don't be afraid of it! There is nothing that inspires me more than color. Walking through the aisles of a scrapbooking store is the most delightful experience for me. Some women like shoes, but I prefer paper!

Most of what you need to know about color is what you learned in elementary school with your first paint box. Mixing primary colors creates secondary colors, and mixing those makes even more. There are a few rules to follow, but the number-one rule is to follow your instincts. When a color combination makes me smile, I go with it.

If you do feel a bit unsure of yourself, you can follow these three basic rules:

1. Stay with one color family. A monochromatic scheme will always work beautifully, and it's easy to follow. Use all pinks or different shades of green.

2. Use the color's next-door neighbors. Colors that sit next to each other on the color wheel can set a beautiful tone for your artwork. For instance, red-violet, red and red-orange can make for a very fiery, exotic piece.

3. Explore opposites. Complementary color schemes are exciting to work with. Can you imagine a plum dress with lemon-yellow accents?

Color choices can be a bit overwhelming sometimes. Scrapbook paper manufacturers make it so easy to work with color. Everything is made to coordinate; all you have to do is choose! I prefer to mix and match my paper choices so the design is truly mine. Whether you use coordinating papers or your own mix, your heart will sing at the right choice!

There are also some rules to follow regarding patterns. When I choose patterns for my projects, I generally follow the rules of interior design. When deciding on patterns for a room, typically we will choose a large-scale print or floral, a small-scale print or floral, and a stripe, plaid or polka dot to match the selected solid color. Think of a set of bedding. A floral comforter may have a striped pattern on the reverse side with small polka-dot or plaid piping. Designing your art will work exactly the same way. This is also how the scrapbook paper companies design their lines. You will have lots of patterns to choose from; it's just a matter of choosing the right proportions for your unique mix.

Setting the Mood

Make yourself an appletini and rim your glass with hot-pink sugar. Dress up your ice cubes with pink rose petals and lavender blossoms, and then add them to sparkling water. Be daring . . . color your lemonade blue!

Setting the Mood

There's no need to shy away from color in your studio or art space! Surround yourself with your favorite hues. Stash supplies in boxes or baskets that scream color. Hang a spice rack and fill the glass bottles with colorful buttons, flowers and other embellishments. Keep a large box of crayons on display and use it when looking for the perfect color accent.

FOLDS AND RUFFLES

The folds of my skirts and dresses create both interest and depth. Each fold should use a different patterned paper than the fold next to it. If the piece is small, I sometimes make the skirt using only one pattern. Remember, there are no hard rules for collage, so do what you want! Keep in mind that the center front of the skirt will always be the last piece to be glued down, and the other pieces will extend from under it.

I won't lie to you about ruffles. They are more complicated to work with, but oh-so worth it! Who wouldn't want a floral skirt with an eyelet ruffle peeking out? I have even created rows and rows of ruffles on a skirt to look like many layers of petticoats. Yes, it made me crazy as I pieced it together, but the end result was breathtaking. In the project *Princess of Hearts* (see page 80), the illusion of a ruffle is made with punched-out paper hearts, which is a very easy way to achieve a ruffly look.

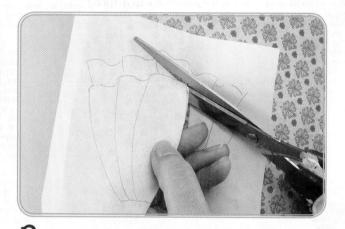

1 Sketch a dress onto tracing paper. If the dress will be worn by a figure, the outfit's proportions should be based on the size of the figure. Every solid line in your sketch represents a cut line for a separate piece in the collage.

2 Place the tracing paper over the first piece of patterned paper you have selected. Cut the middle fold of the skirt or dress.

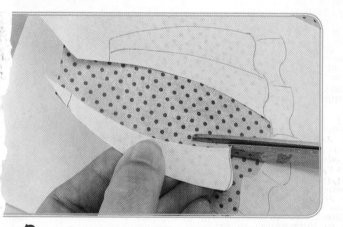

3 Continue cutting each fold using a different patterned paper. When you cut these pieces, it is important to leave a small allowance of patterned paper extending past the cut line for layering purposes.

Tip

If you have trouble keeping the tissue paper still while you cut, use repositionable tape to stick it to the patterned paper you are cutting.

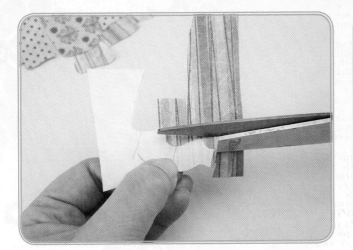

4 Begin cutting the ruffle pieces, starting with the center ruffle. For each piece, leave a small allowance of patterned paper extending past the cut line for layering purposes.

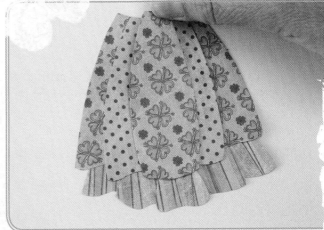

5 Position the ruffle on the background of your choice. The center ruffle should be on top with the other ruffles layered beneath and extending from each side. Secure the ruffles with decoupage medium.

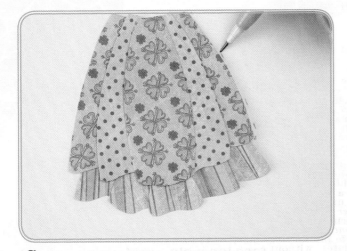

6 Begin placing the folds above the ruffle so they overlap the ruffle slightly. Again, the fold in the center is on top with the other folds layered beneath it, extending from each side. When the pieces are arranged to your liking, use a pencil to mark the position of the end folds.

7 Working from the outside in, secure the fold pieces with decoupage medium. Glue down the center fold. The skirt is finished!

PUTTING THE FIGURE TOGETHER

The first time you assemble a figure might be a bit tedious, so you may want to go pour yourself a big cup of coffee to get you through it. Keep your original sketch intact so you can use it as a guide for your layout. Trace your sketch onto tracing paper to use as your pattern. It will be cut up into little pieces along with the patterned paper.

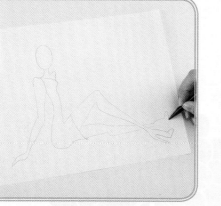

1 Use the sketching techniques on pages 10–15 to sketch a figure and her outfit onto tracing paper with a pencil.

2 Layer a second piece of tracing paper over the first. If one of the legs is overlapped by the other, trace the back leg onto the second piece of tracing paper.

3 Trace the outfit onto the second piece of tracing paper.

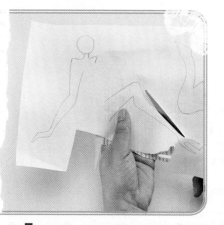

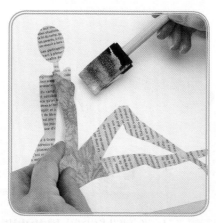

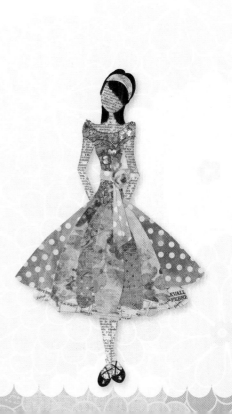

4 Place a piece of patterned paper beneath each traced part of the figure and cut along the lines. Repeat this process for the dress.

5 Using decoupage medium and a foam brush, adhere the different pieces of the figure to the background of your choice. Use the original sketch from Step 1 as a guide for placing the different pieces.

BACKGROUND TECHNIQUES

Put on your smock and get out your paintbrushes—it's playtime! In this section, I will show you my tricks for creating a smooth, cohesive look for all of your collage elements. These backgrounds are simple to do, and they create a lot of texture. I prefer a well-blended background so my girls will stand out. Again, you will develop your own style and may prefer a choppier or messier look, which is fine too.

Sponging

I almost always start my backgrounds using the Sponging technique. Using a natural sea sponge adds a subtle depth, which will work as a great base either alone or with other techniques.

1 Paint a base coat on the project surface in the desired color(s). Using a damp natural sea sponge, apply a slightly darker color than the base coat.

2 To apply a second color, allow the first color to dry. You may need to apply more of the first color to achieve the desired effect.

Tip

For more pronounced and separated colors, sponge each color separately, letting the paint dry completely between applications. For more muted and blended colors, apply several colors at the same time with a slightly wetter sponge.

Stamping

I know that there isn't much explanation that goes with stamping. It's pretty basic, isn't it? I do find that it's best to use foam stamps rather than rubber-mounted stamps on a canvas surface because foam stamps produce a cleaner, crisper image.

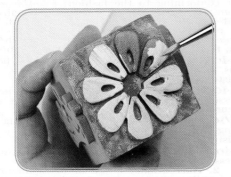

1 Paint 2 base coats on the project surface with the desired color(s). Make sure the surface is smooth. Paint the stamp with the desired color using a small paintbrush.

2 Press the stamp firmly onto the dry surface. Lift carefully to avoid smearing the design.

3 Create depth by layering several of the same image in different colors.

Paper Collage

This is one of my favorite background techniques. For a subtle effect, I will use similar colors, but it's always fun to throw a bit of contrast into the mix, too.

1 Paint a base coat on the project surface with the desired color(s). If you are using only opaque papers, you need only paint the edges of the surface. Tear or cut pieces of patterned paper and/or tissue paper. Brush decoupage medium on a small part of the surface and place a piece of paper on top.

2 Layer several pieces over still-wet decoupage medium. Brush the medium on top of them.

3 If desired, smooth out any wrinkles in the papers.

Tip

When smoothing out the patterned paper, you want to smooth it out as much as possible, but most of the air bubbles will dry flat anyway.

Bubble Wrap

Paint applied with Bubble Wrap can add such whimsy to a piece. I often use this technique with decoupaged torn paper. I will also apply a layer of white Bubble Wrap texture to brighten a piece up a bit.

1 Paint a base coat on the project surface with the desired color(s). Cut a piece of Bubble Wrap 2"–3" (5cm–7.5cm) wide and the length of the surface. Brush a light coat of acrylic paint onto the bubble side.

2 Press the Bubble Wrap onto a painted canvas board. Press lightly in some sections to apply the paint unevenly. Carefully pull the Bubble Wrap from the surface.

3 To add depth, wait for the initial texture to dry, and then apply another layer of Bubble Wrap texture with a different color.

Brayer

This technique can be used for a solid base coat, but it also works wonderfully on a paper collage background.

1 Paint a base coat on the project surface with the desired color(s). Pour a small amount of a contrasting color of paint onto a flat palette surface or a piece of scrap paper. Roll the brayer through the contrasting color.

2 Roll the brayer over the surface, rolling in different directions to create a messy look. This technique works best if the brayer has a thin coat of paint rather than a thick one.

3 To add depth, wait for the initial application to dry and then apply a second color with the brayer.

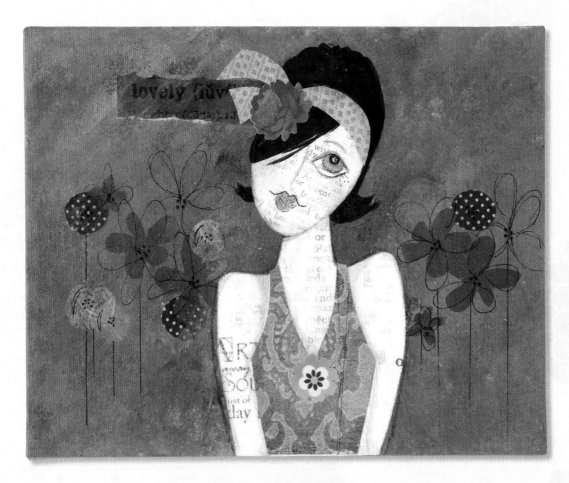

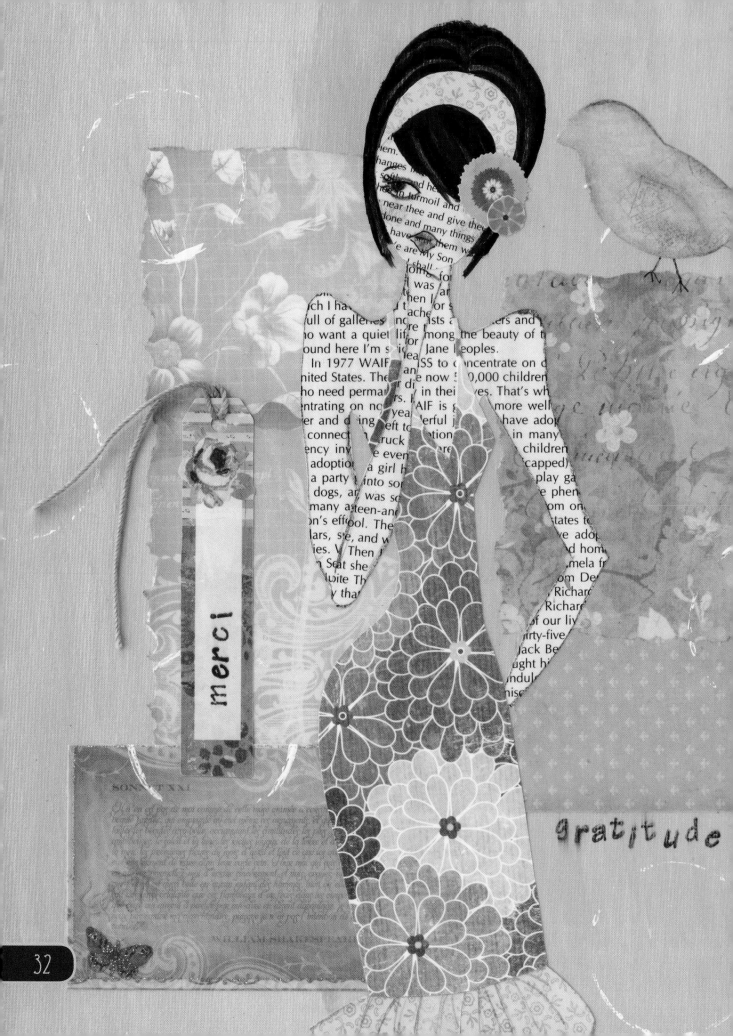

Fashion ON CANVAS

The projects in this chapter are all completed on 11" × 14" (28cm × 35.5cm) canvas boards. Wood or wrapped canvas can also be used. Although I do use wrapped canvas a lot, the boards are easier to use because they are solid and inflexible. The boards can be framed, but they also look great sitting on photo ledges. Of course, wrapped canvas can be hung as is. The 11" × 14" (28cm × 35.5cm) size is perfect for beginners; if you work on a smaller board than this, the figure and outfit become smaller and more difficult to work with.

I find my inspiration for these pieces in many places. I usually browse through fashion images on the Internet or in magazines for great pose ideas. I then turn to my yummy paper collection and set to work pulling various patterns and colors.

As you start your projects, think of different ways to make yours special. Perhaps you love all things Italian. Find a street map of Rome online and copy it to use. If you love entertaining, use a drink recipe from a vintage book. Be sure to start saving paper menus and tourist newspapers from your travels. They are sure to come in handy for a future project.

Feel free to change up the poses, colors and materials in these projects. You will be surprised at the results when you use your imagination. Let's get started!

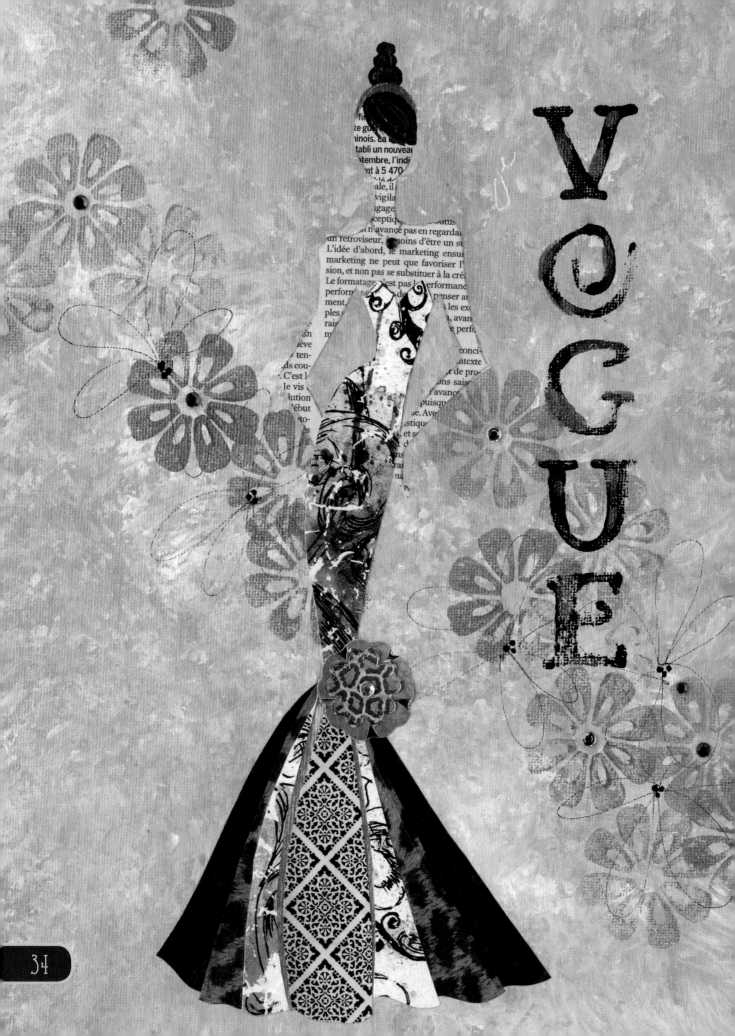

VOGUE

This fashionista is definitely the glamour girl of the bunch! I recommend starting with this piece because it is by far the easiest to piece together and the background is simple. From the dress design to the hairstyle to the background, this piece proves that you don't need a lot of bells and whistles to be *en vogue*.

MATERIALS

11" × 14" (28cm × 35.5cm) canvas board

acrylic paints in khaki, white, black, camel, metallic gold, metallic bronze and metallic copper

assorted patterned paper

black colored pencil

black fine-tip permanent marker

black medium-tip permanent marker

decoupage medium

flower embellishment

high-quality acrylic paint in raw umber

newsprint paper

pencil

pink chalk

self-adhesive rhinestones

tracing paper

TOOLS

alphabet stamps

cotton swab

fine-tip paintbrush

flower stamp

foam brush

natural sea sponge

TECHNIQUES

Sketching a Fashion Figure (page 10)

Facial Features and Hair (page 16)

Sketching Clothing (page 20)

Folds and Ruffles (page 26)

Putting the Figure Together (page 28)

Sponging (page 29)

Stamping (page 29)

Setting the Mood

Pour a martini from an old-fashioned cocktail shaker. An olive is a must! Too early for this? How about seltzer water with lime in an elegant crystal glass? Light some scented candles, close your eyes and pretend you're a glamorous movie star.

35

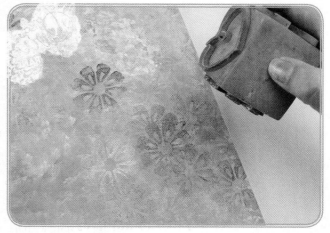

1 Paint the canvas board with 2 base coats of khaki acrylic paint to achieve an even consistency. Using the Sponging technique, apply khaki, white, and camel paint to the board, allowing each color to dry before applying the next.

2 Using the Stamping technique, stamp the board with a flower stamp and gold, bronze and copper metallic paint. Start in the upper left corner of the board and stamp diagonally down to the lower right corner.

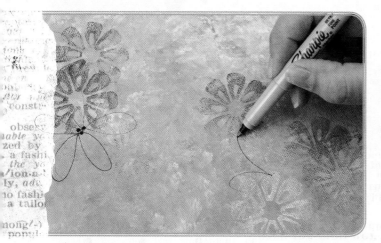

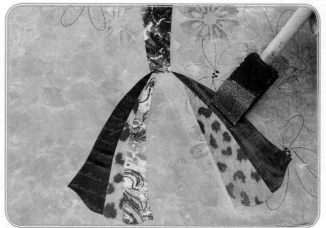

3 Freehand draw large-petaled flowers over the stamped flowers with a black fine-tip permanent marker. Dot the center of each flower 3 times with a black medium-tip permanent marker.

4 Sketch a figure and her outfit, and trace them onto tracing paper. Use the sketch to cut out the figure using newsprint paper; cut out the dress using patterned paper of your choice. Using a black colored pencil, outline the edges of the figure. Decoupage the pieces to the board.

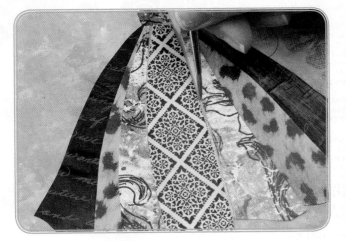

5 If the folds of the dress don't fit together perfectly, fill in the gaps with metallic gold paint.

6 At the top of the figure's head, paint a thin headband with metallic gold. Using a high-quality acrylic paint and a fine-tip paintbrush, paint the hair onto the figure with raw umber, painting around the headband. Let the paint dry. Highlight the hair with metallic gold paint. Paint a necklace around the figure's neck with metallic gold paint. Use pink chalk and a cotton swab to highlight the cheeks on the figure's face.

7 Using the Stamping technique, stamp the letters V, O, G, U and E down the right side of the board in black paint. Let the paint dry. Paint each letter stamp with gold splotches and stamp over the letters again.

8 Glue a flower embellishment to the figure's dress. Adhere self-adhesive rhinestones to some of the stamped flower centers. Adhere a rhinestone to the center of the figure's necklace.

Apply 2 coats of decoupage medium to the entire board to seal and finish.

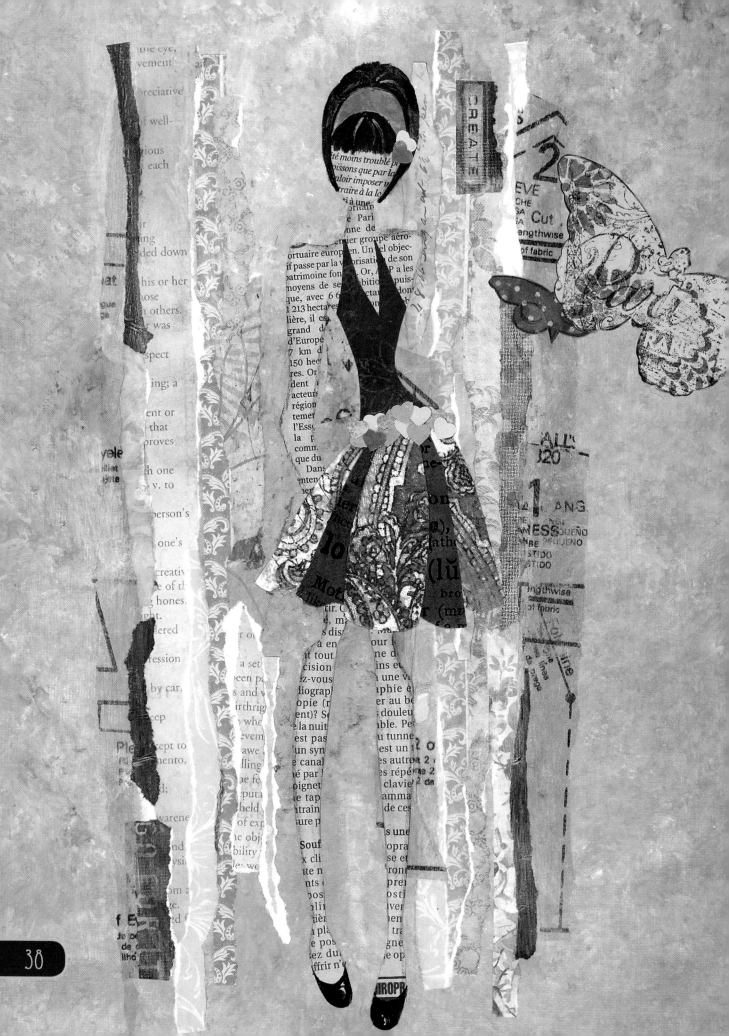

CHOCOLATE STRAWBERRIES

Doesn't she look just yummy? I love pink and brown together; they make me feel like having dessert! Whether it's ice cream, cupcakes or chocolate-covered strawberries, this color combination suggests dessert time, and I'm ready to eat it up! You will be using the Sponging and Paper Collage techniques to create this sweet work of art. The tiniest of heart punches was used to embellish her dress. They're like the cherries on top of a hot fudge sundae!

MATERIALS

11" × 14" (28cm × 35.5cm) canvas board

acrylic paints in white, khaki, light pink and metallic gold

assorted patterned paper in pinks and browns

black fine-tip permanent marker

brown colored pencil

brown ink

decoupage medium

different shades of pink cardstock

high-quality acrylic paints in raw umber and burnt sienna

newsprint paper

patterned tissue paper

pencil

pink chalk

small and large butterfly stencils

tracing paper

TOOLS

cotton swab

fine-tip paintbrush

foam brush

large Paris-script stamp

natural sea sponge

scissors

small heart punch

TECHNIQUES

Sketching a Fashion Figure (page 10)

Facial Features and Hair (page 16)

Sketching Clothing (page 20)

Folds and Ruffles (page 26)

Putting the Figure Together (page 28)

Sponging (page 29)

Paper Collage (page 30)

Setting the Mood

This is the perfect project to work on while appeasing your sweet tooth. Make yourself a cup of rich, creamy hot chocolate topped with pink marshmallows. Too hot for a warm drink? How about a chocolate martini?

1 Paint the canvas board with a base coat of khaki acrylic paint. Let the paint dry.

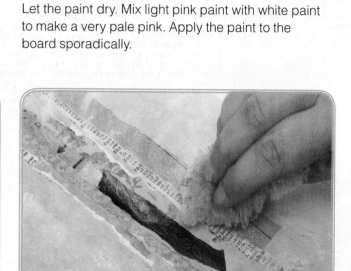

2 Using the Sponging technique, apply khaki and white paint to the board at the same time. Let the paint dry. Mix light pink paint with white paint to make a very pale pink. Apply the paint to the board sporadically.

3 Tear strips of pink and brown patterned paper, patterned tissue paper and newsprint paper in varying lengths and widths. Adhere the strips down the length of the board with decoupage medium and a foam brush.

4 Using a wet natural sea sponge, apply a touch of white paint to the strips. Let the paint dry.

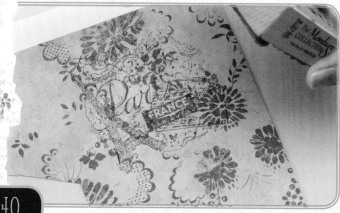

5 Trace or draw a large butterfly onto a piece of patterned paper. Stamp over the butterfly with a large Paris-script stamp and brown ink. Cut it out.

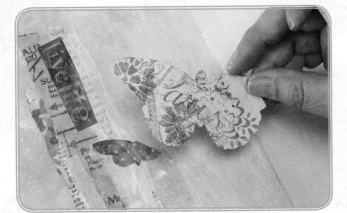

6 Trace or draw a small butterfly onto patterned paper and cut it out. Place the large stamped butterfly on the right edge of the board with one wing extending past the edge. Trim the excess paper. Adhere both butterflies to the board with decoupage medium.

7 Sketch a figure, her outfit and a headband, and trace them onto tracing paper. Use your sketch to cut out the figure using newsprint paper; cut out the outfit using patterned paper of your choice. Using a brown colored pencil, outline the edges of the figure. Decoupage the pieces to the board.

8 Use a small heart punch to punch several hearts in different shades of pink cardstock. Adhere the hearts around the figure's waist with decoupage medium.

9 Using a high-quality acrylic paint and a fine-tip paintbrush, paint the hair onto the figure with raw umber. Let the paint dry. Highlight the hair with burnt sienna and metallic gold paint. Once the paint is dry, glue a pink heart punch to the side of the headband with decoupage medium. Use pink chalk and a cotton swab to highlight the cheeks on the figure's face.

10 Using a black fine-tip permanent marker, outline and then color in the shoes. To create highlights, leave small squiggles of the shoes uncolored.

Apply 2 coats of decoupage medium to the entire board to seal and finish.

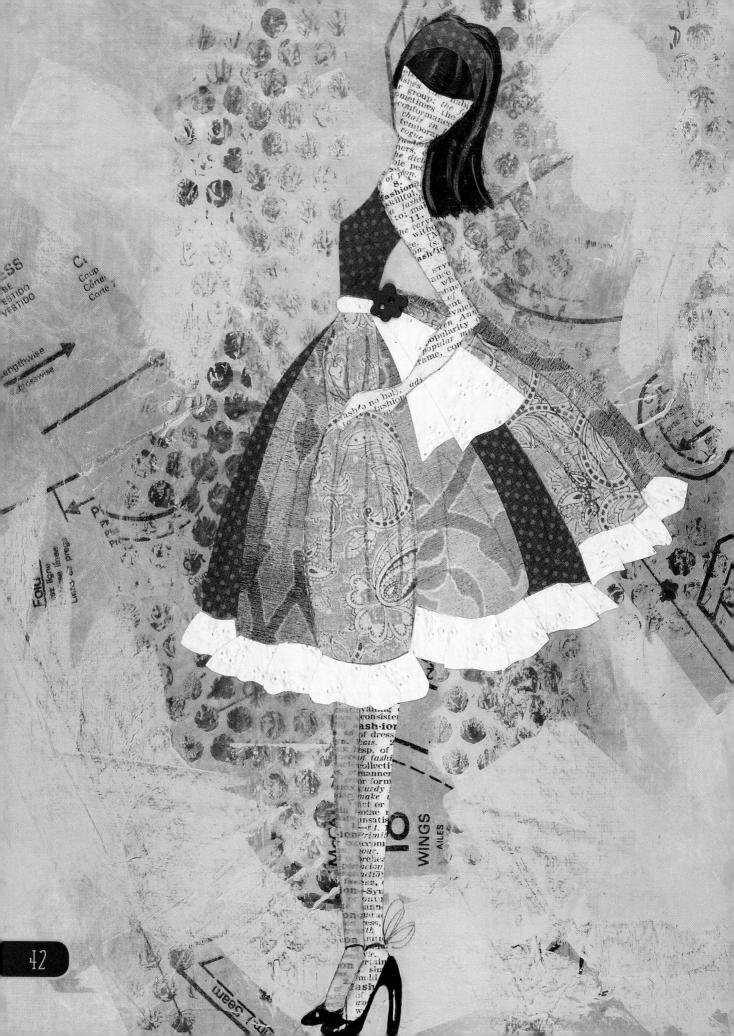

HOW DO I LOOK?

The girl in this piece seems to be saying, "Does this make me look like a princess?" I think the answer would be a big *Yes*! In this project, you will learn how to spread paint across a surface with an old credit card or gift card. I used completely contrasting colors for the background, and I love the way it turned out. I used patterned tissue paper for the base and made sure to keep a few wrinkles for texture.

MATERIALS

11" × 14" (28cm × 35.5cm) canvas board

acrylic paints in khaki, pale yellow, pale blue, denim blue, dark brown and metallic gold

assorted patterned paper, including text-patterned paper

black fine-tip permanent marker

colored pencils, including brown

decoupage medium

flower-shaped button

high-quality acrylic paint in raw umber

patterned tissue paper

pencil

pink chalk

tracing paper

TOOLS

Bubble Wrap

cotton swab

craft glue

fine-tip paintbrush

foam brush

old credit card or gift card

scissors

TECHNIQUES

Sketching a Fashion Figure (page 10)

Facial Features and Hair (page 16)

Sketching Clothing (page 20)

Folds and Ruffles (page 26)

Putting the Figure Together (page 28)

Paper Collage (page 30)

Bubble Wrap (page 30)

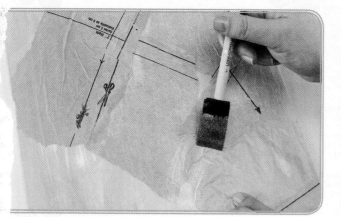

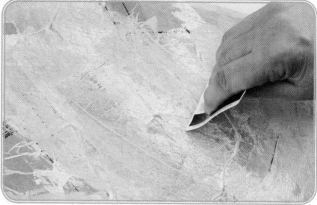

1 Paint the canvas board with a base coat of khaki acrylic paint. Let the paint dry. Using the Paper Collage technique, layer large pieces of torn patterned tissue paper onto the board with decoupage medium. Some pieces should extend past the edges of the board and fold over the other side. Let the medium dry completely.

2 Dip an old plastic credit card or gift card into pale yellow paint. Sweep the card across the board several times, creating a messy look. Repeat this step with pale blue paint.

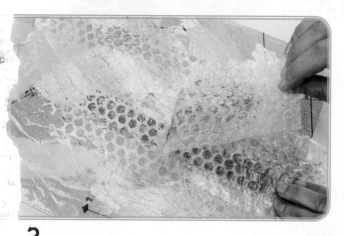

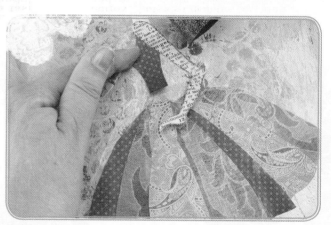

3 Using the Bubble Wrap technique, apply a Bubble Wrap texture with denim blue paint. Let the paint dry, and then repeat with dark brown paint. Apply the texture so it will frame the figure in the center of the board.

4 Sketch a figure, her dress and a headband, and trace them onto tracing paper. Use your sketch to cut out the figure using text-patterned paper; cut out the dress and headband using patterned paper of your choice. Using a brown colored pencil, outline the edges of the figure. Decoupage the pieces to the board, leaving the end of the arm unglued.

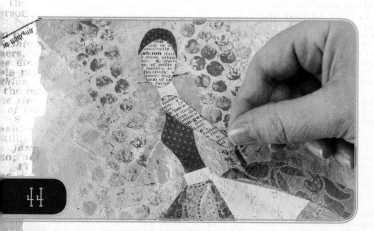

5 Cut a small strip of paper to fit the waist of the figure. Cut 2 triangular sash shapes. Adhere the sash to the figure with decoupage medium. Place the arm over the sash.

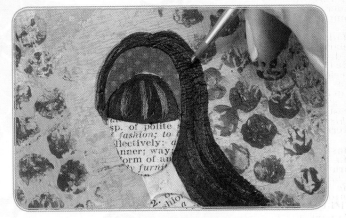

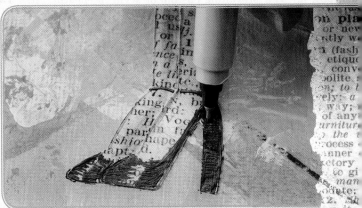

6 Using a high-quality acrylic paint and a fine-tip paintbrush, paint the hair onto the figure with raw umber. Let the paint dry. Highlight the hair with metallic gold paint. Use pink chalk and a cotton swab to highlight the cheeks on the figure's face.

7 Using a black fine-tip permanent marker, outline and then color in the shoes. To create highlights, leave small squiggles of the shoes uncolored.

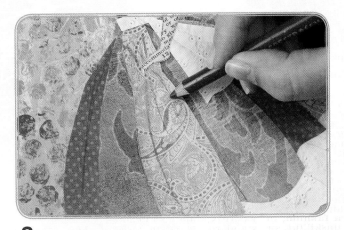

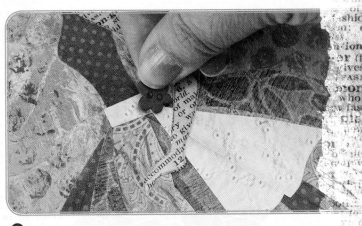

8 Accentuate the folds of the dress by drawing lines with a colored pencil in a complementary color.

9 Using craft glue, adhere a flower-shaped button where the 2 points of the triangular sash pieces meet the belt.

Apply 2 coats of decoupage medium to the entire board to seal and finish.

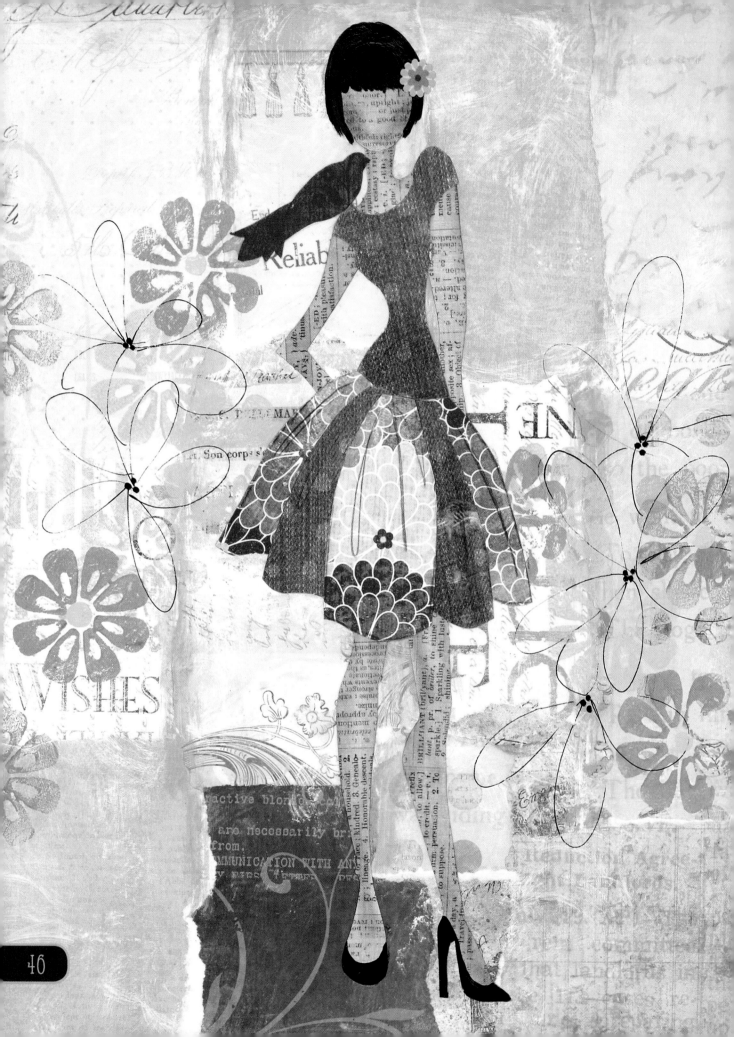

DENIM GIRL

Denim just seems like a natural choice to pair with 1970s-style flowers, doesn't it? You will be using the Paper Collage technique combined with flower stamps in bright, happy colors.

MATERIALS

11" × 14" (28cm × 35.5cm) canvas board

acrylic paints in khaki, white, light pink, hot pink and pale yellow

assorted patterned paper, including text-patterned paper

bird stencil

black fine-tip permanent marker

black medium-tip permanent marker

colored pencils, including brown

decoupage medium

high-quality acrylic paints in raw umber and burnt sienna

pencil

pink chalk

tiny die-cut flower

tracing paper

TOOLS

cotton swab

fine-tip paintbrush

flower stamp

foam brush

natural sea sponge

scissors

TECHNIQUES

Sketching a Fashion Figure (page 10)

Facial Features and Hair (page 16)

Sketching Clothing (page 20)

Folds and Ruffles (page 26)

Putting the Figure Together (page 28)

Sponging (page 29)

Stamping (page 29)

Paper Collage (page 30)

Setting the Mood

Relax, kick back and enjoy the mellow vibe this piece brings. Pour a cup of herbal tea in a colorful mug and wear your shabbiest jeans. Break out your collection of 1970s music and hum along!

1 Paint around the edges of the board with khaki. Using the Paper Collage technique, cover the white space on the board with torn blocks of patterned paper.

2 Using the Sponging technique, sponge over the paper with a mix of khaki and white paint. Let the paint dry.

3 Using the Stamping technique, stamp the board with a flower stamp and light pink and hot pink paint. Start in the upper left corner of the board and stamp diagonally down to the lower right corner. Paint the centers of the flowers with pale yellow.

4 Draw large-petaled flowers over the stamped flowers with a black fine-tip permanent marker. Dot the center of each flower 3 times with a black medium-tip permanent marker.

5 Sketch a figure and her outfit, and trace them onto tracing paper. Use your sketch to cut out the figure using text-patterned paper; cut out the dress using patterned paper of your choice. Using a brown colored pencil, outline the edges of the figure. Decoupage the pieces to the board.

6 Trace or draw a bird onto patterned paper and decoupage it sitting on the figure's shoulder.

7 Using a high-quality acrylic paint and a fine-tip paintbrush, paint the hair onto the figure with raw umber. Let the paint dry. Highlight the hair with burnt sienna. Use pink chalk and a cotton swab to highlight the cheeks on the figure's face. Glue a tiny die-cut flower to the figure's hair with decoupage medium.

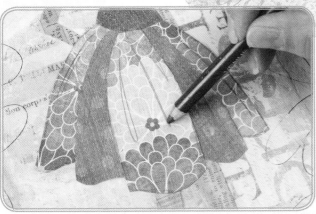

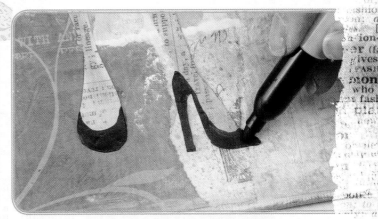

8 Accentuate the folds of the dress with a colored pencil in a complementary color.

9 Using a black medium-tip permanent marker, outline and then color in the shoes.
 Apply 2 coats of decoupage medium to the entire board to seal and finish.

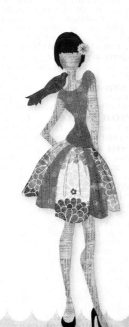

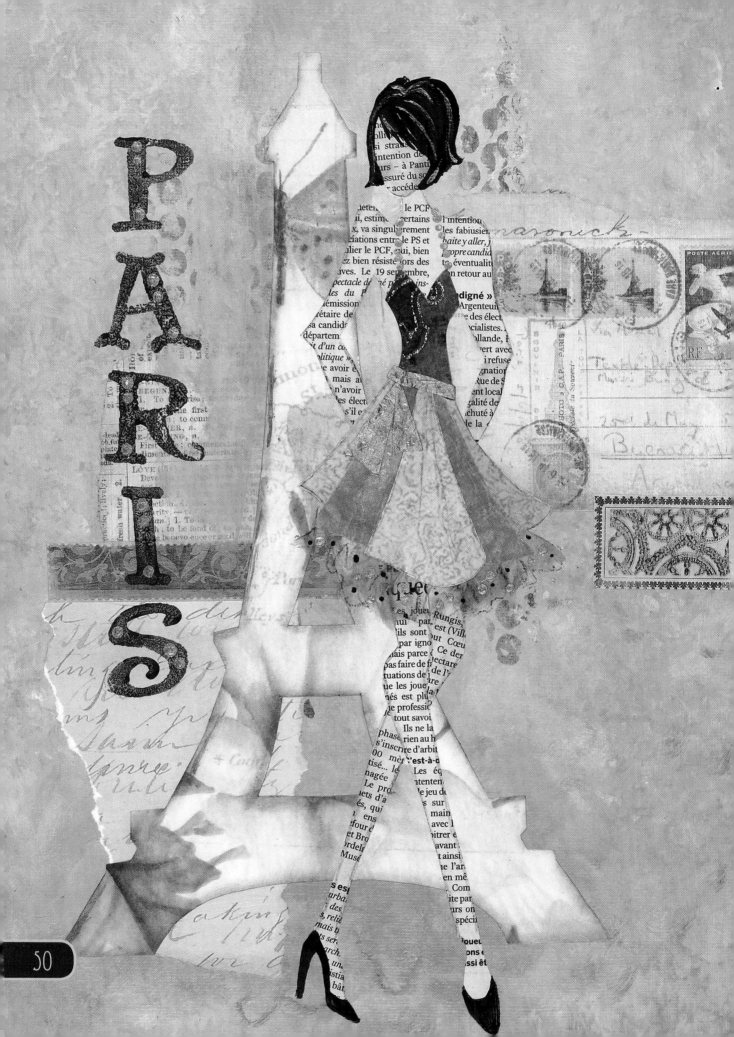

POSTCARD FROM PARIS

It goes without saying: Paris and couture go hand in hand. I can't think of anything more inspiring than the most romantic city in the world. In this project, a large silhouette of the Eiffel Tower dominates the background, while Sponging, Bubble Wrap and Paper Collage textures complement the *belle femme*.

MATERIALS

11" × 14" (28cm × 35.5cm) canvas board

acrylic paints in khaki, white, lavender, chocolate brown and metallic gold

assorted patterned paper, including text-patterned paper and French-themed paper

black medium-tip permanent marker

brown and pink chalk

brown colored pencil

decoupage medium

Eiffel Tower stencil

gold metallic paper

green mulberry paper

high-quality acrylic paint in raw umber

pencil

tracing paper

vintage postcard

TOOLS

alphabet stamps

Bubble Wrap

cotton swab

fine-tip paintbrush

foam brush

natural sea sponge

scissors

TECHNIQUES

Sketching a Fashion Figure (page 10)

Facial Features and Hair (page 16)

Sketching Clothing (page 20)

Folds and Ruffles (page 26)

Putting the Figure Together (page 28)

Sponging (page 29)

Paper Collage (page 30)

Bubble Wrap (page 30)

Setting the Mood

The color lavender always comes to mind whenever I think of France. Try this simple recipe for lavender tea: Add a teaspoon of dried lavender flowers to a cup of black or green tea. Sweeten with lavender sugar to your taste. Make sure to drink it from a fabulous floral teacup!

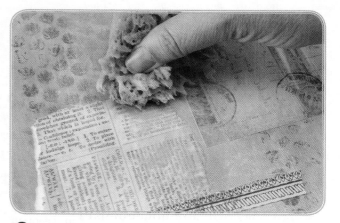

1 Paint a canvas board with a base coat of khaki acrylic paint. Let the paint dry. Using the Sponging technique, apply chocolate brown, white and khaki paint to the board, allowing each color to dry before applying the next. Using the Bubble Wrap technique, apply a Bubble Wrap texture with lavender paint. Let the paint dry, and then repeat with chocolate brown paint. Apply the texture so it will frame the figure in the center of the board.

2 Using the Paper Collage technique, decoupage torn pieces of French-themed paper, such as the back of a vintage postcard or paper with a French script. Use a wet natural sea sponge and khaki paint to apply a wash along the edges of the papers to blend them with the background.

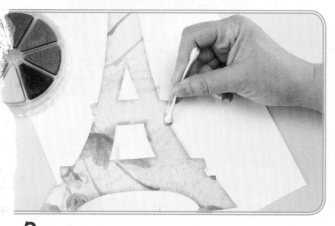

3 Trace and cut out the shape of the Eiffel Tower onto a piece of patterned paper. Rub the edges with brown chalk and a cotton swab.

4 Decoupage the Eiffel Tower to the board slightly off-center.

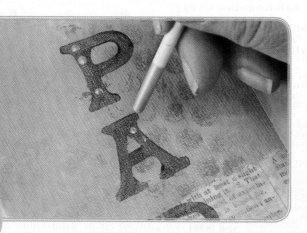

5 Stamp the letters P, A, R, I and S down the left side of the board with alphabet stamps and chocolate brown acrylic paint. Add dots of metallic gold paint to the letters with the wrong end of a fine-tip paintbrush.

6 Sketch a figure and her outfit, and trace them onto tracing paper. Use your sketch to cut out the figure using text-patterned paper; cut out the outfit using patterned paper of your choice. Create a ruffled hem using small torn pieces of green mulberry paper. Using a brown colored pencil, outline the edges of the figure's body. Decoupage the pieces to the board.

7 Cut a small strip of gold metallic paper to fit around the figure's waist. Cut 2 triangle sash shapes. Decoupage them onto the figure.

8 Using a high-quality acrylic paint and a fine-tip paintbrush, paint the hair onto the figure with raw umber. Let the paint dry. Highlight the hair with metallic gold paint. Use pink chalk and a cotton swab to highlight the cheeks on the figure's face. Create straps for the figure's top with dots of metallic gold paint.

9 Using a black medium-tip permanent marker, outline and then color in the shoes. To create highlights, leave small squiggles of the shoes uncolored.

10 Apply dots of metallic gold paint to the dress ruffle. Add small accent streaks of metallic gold paint down the side of the Eiffel Tower.
Apply 2 coats of decoupage medium to the entire board to seal and finish.

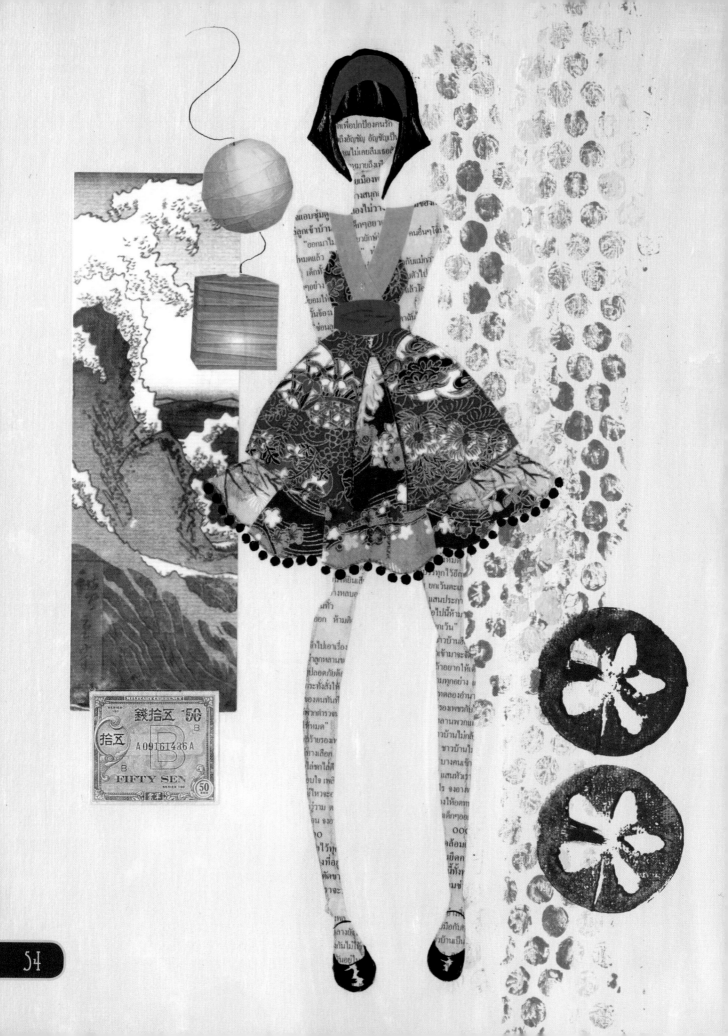

CHOPSTICKS

My husband came home from a mission trip and brought me newspapers and magazines from Thailand. I was inspired to create an Asian girl and immediately looked through all my ephemera for goodies to go with this piece. After completing all the decoupage, I wanted something really pronounced and really red for the background. I didn't have an appropriate stamp, so I found myself at the kitchen table carving a potato. I think it added the perfect touch!

MATERIALS

11" × 14" (28cm × 35.5cm) canvas board

acrylic paints in pale yellow, white, camel, pale blue, red and metallic gold

Asian collage elements, including paper lanterns

Asian newsprint or Asian script-patterned paper

assorted Asian-themed patterned paper

black colored pencil

black fine-tip permanent marker

black medium-tip permanent marker

decoupage medium

high-quality acrylic paint in raw umber

pencil

pink chalk

tracing paper

TOOLS

awl

Bubble Wrap

cotton swab

fine-tip paintbrush

foam brush

scissors

small potato

TECHNIQUES

Sketching a Fashion Figure (page 10)

Facial Features and Hair (page 16)

Sketching Clothing (page 20)

Folds and Ruffles (page 26)

Putting the Figure Together (page 28)

Stamping (page 29)

Paper Collage (page 30)

Bubble Wrap (page 30)

Setting the Mood

This piece will set your sights on the faraway East. Hang colorful paper lanterns in your art space and have a basket of fortune cookies to munch on. Don't throw the fortunes away; you can use them on your artwork!

1 Paint a canvas board with a base coat of pale yellow and white. The coat of paint shouldn't be too even; leave it a little streaky. Let the paint dry. Using the Bubble Wrap technique, apply a Bubble Wrap texture to the right side of the board with camel paint. Let the paint dry, and then repeat with pale blue paint.

2 Decoupage several different-sized rectangles of Asian-themed patterned papers on the lower left side of the board.

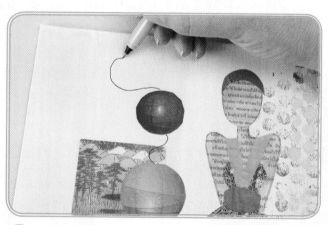

3 Sketch a figure, dress and headband, and trace them onto tracing paper. Use your sketch to cut out the figure using Asian newsprint; cut out the dress and headband using patterned paper of your choice. Using a black colored pencil, outline the edges of the body parts. Decoupage the figure to the board.

4 Decoupage paper lanterns onto the board to the left of the figure. With a black fine-tip permanent marker, draw strings between the lanterns.

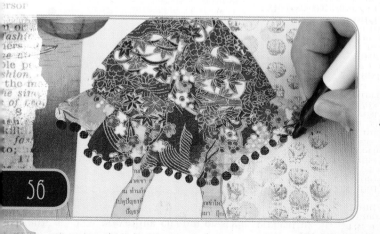

5 Draw a ball fringe onto the hem of the dress with a black medium-tip permanent marker.

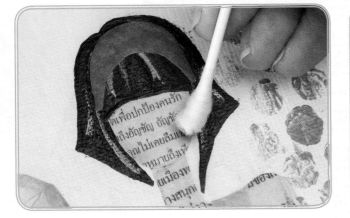

6 Using a high-quality acrylic paint and a fine-tip paintbrush, paint the hair onto the figure with raw umber, painting around the headband. Let the paint dry. Use metallic gold paint to highlight the hair. Use pink chalk and a cotton swab to highlight the cheeks on the figure's face.

7 Using a black fine-tip permanent marker, outline and then color in the shoes. To create highlights, leave small squiggles of the shoes uncolored.

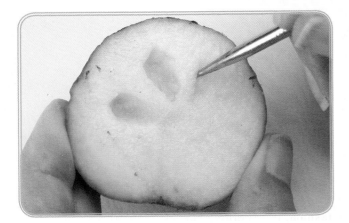

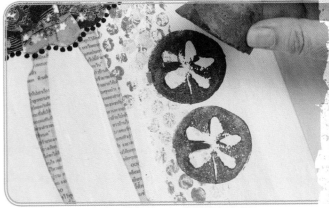

8 Cut a small potato in half and draw 5 flower petals on its surface. Carve the petals out with an awl, and then scoop out the negative space.

9 Using the Stamping technique, stamp the potato stamp onto the lower right side of the board with red paint.

Apply 2 coats of decoupage medium to the entire board to seal and finish.

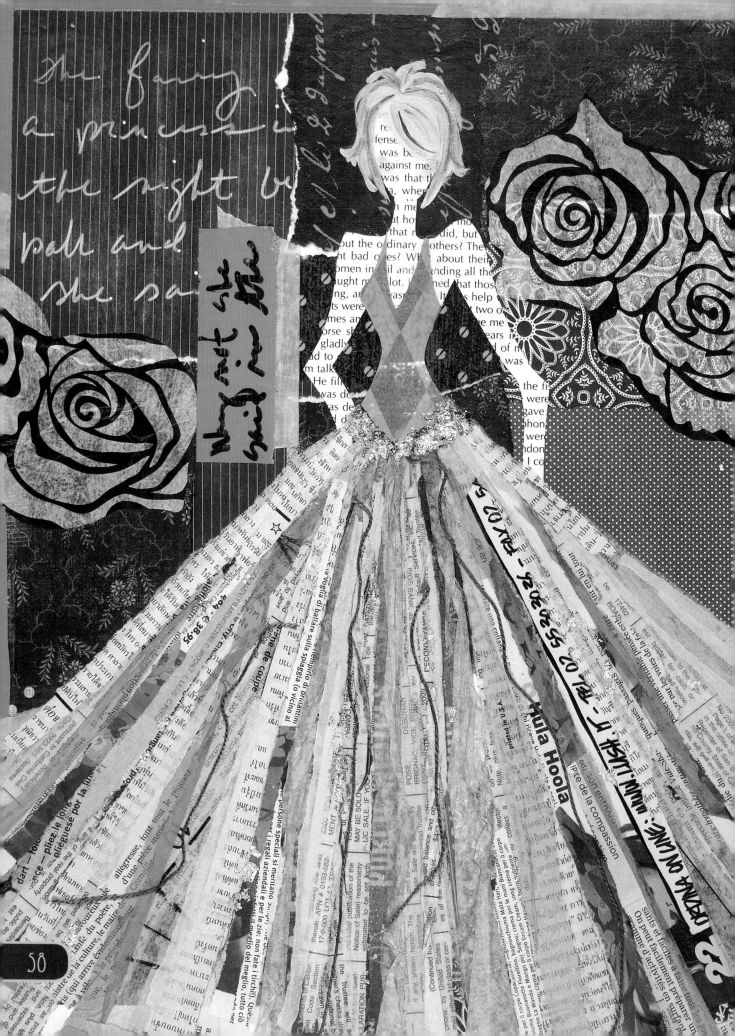

NEWSPAPER HEIRESS

I collect newspapers from all over the world. Lots of girls get jewelry as gifts, but I get newspapers and couldn't be happier! I loved the thought of using strips of newspaper and magazines for a dress. I incorporated a burst of color by using a roll of turquoise duct tape that had been sitting on my shelf for a very long time. Down it came, along with the roll of masking tape next to it. The same shade of turquoise is mirrored in strips of decoupaged tissue paper.

MATERIALS

11" × 14" (28cm × 35.5cm) canvas board

assorted newspaper, magazine and old book pages

assorted patterned paper in black-and-white and black-and-gold, and text-patterned paper

black medium-tip permanent marker

decoupage medium

gold leaf

high-quality acrylic paints in golden yellow and burnt sienna

masking tape

patterned tissue paper, including rose-patterned tissue paper

pencil

pink chalk

tracing paper

turquoise duct tape

turquoise embroidery floss

turquoise tissue paper

white marker

TOOLS

cotton swab

fine-tip paintbrush

foam brush

scissors

TECHNIQUES

Sketching a Fashion Figure (page 10)

Facial Features and Hair (page 16)

Sketching Clothing (page 20)

Putting the Figure Together (page 28)

Paper Collage (page 30)

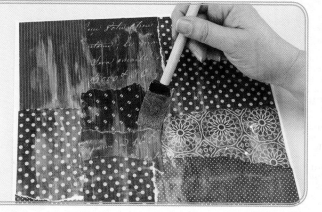 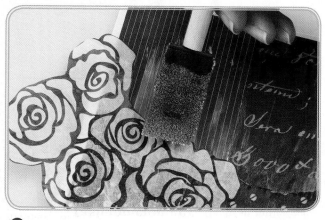

1 Using the Paper Collage technique, decoupage torn pieces of prominently black patterned paper onto a canvas board. Only cover the top three-fourths of the board, because the bottom fourth is covered by the figure's dress.

2 Cut 2 clusters of roses from patterned tissue paper and decoupage them to the board. They should extend past the edge of the board slightly; fold the excess over the board and adhere it on the other side with the decoupage medium. Let the board dry.

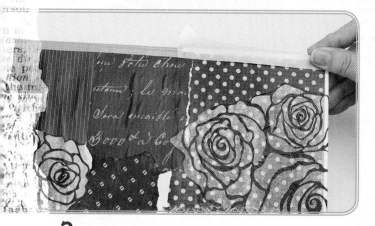 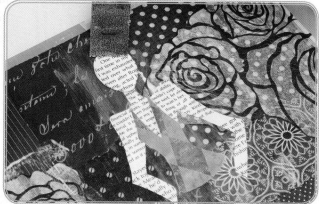

3 Alternating varying lengths of turquoise duct tape and masking tape, wrap the edges of the collaged portion of the board.

4 Sketch a figure and her bodice, and trace them onto tracing paper. Use your sketch to cut out the figure using newsprint or text-patterned paper; cut out the bodice using patterned paper of your choice. Decoupage the pieces to the board.

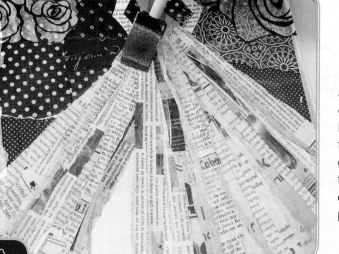

5 Tear newspaper, magazine pages, book pages, patterned and turquoise tissue paper, and assorted patterned paper into strips that are long enough to extend from the figure's waist to over the bottom edge of the board. Decoupage the strips to the board to form a ball gown, starting at the waist and extending past the edge of the board. Wrinkle and twist the tissue paper strips for added texture. Trim the excess from the strips. It is okay if the strips extend past the edge a little.

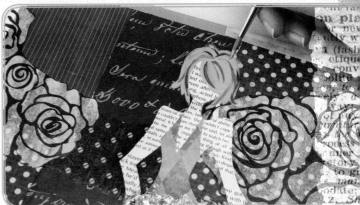

6 Tear thin strips of masking tape and adhere them to the ball gown. Decoupage pieces of gold leaf onto the gown and along the waistline to make a belt. Add another coat of decoupage medium to the entire ball gown. Adhere strands of turquoise embroidery floss to the ball gown while the medium is still wet.

7 Using a high-quality acrylic paint and a fine-tip paintbrush, paint the hair onto the figure with golden yellow. Let the paint dry. Highlight the hair with burnt sienna. Use pink chalk and a cotton swab to highlight the cheeks on the figure's face.

8 Using a white marker, journal in the upper left corner of the piece over the black patterned paper.

9 Cut a small piece of masking tape and adhere it to the left of the figure. Layer a small piece of turquoise duct tape over the masking tape. Journal with a black medium-tip permanent marker on the duct tape.

Apply 2 coats of decoupage medium to the entire board to seal and finish.

Tip

Collect newspapers whenever you travel. I often use newspapers from foreign countries in my work and purposefully include the date from the paper in my piece as a little souvenir of my trip.

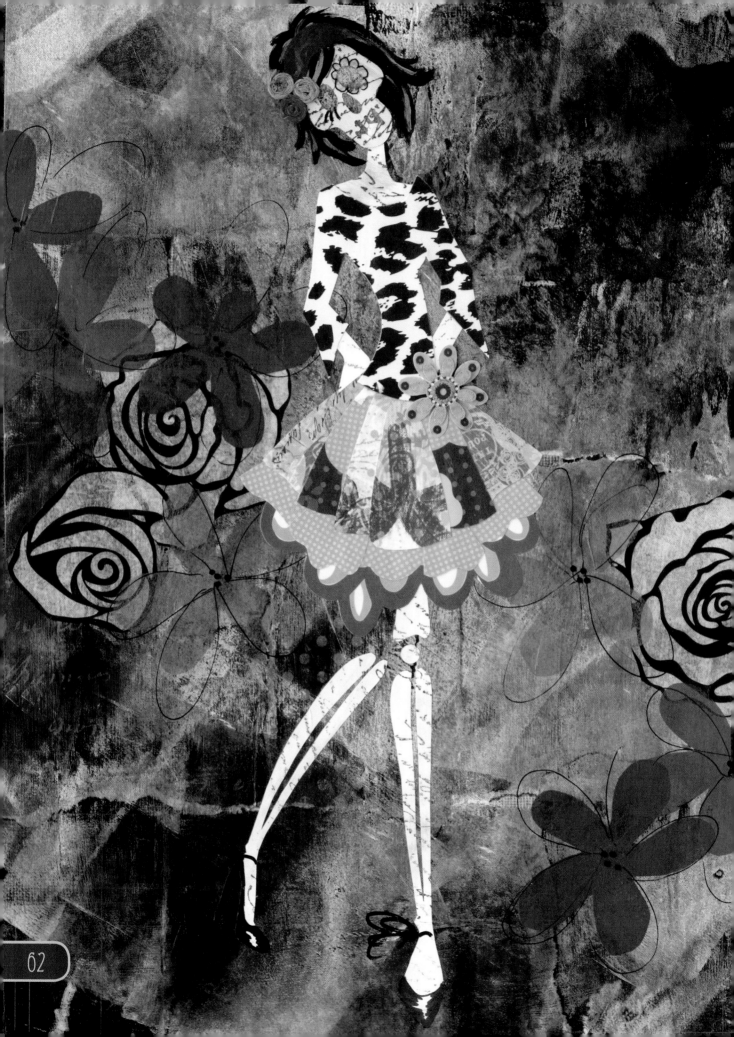

LA BAMBA

I am lucky to live in Southern California where a colorful, festive mix of Mexican culture is constantly present. Day of the Dead art and figurines are in abundance here, and I must admit I love to use them in my art. You can go absolutely crazy with the colors; the brighter they are, the better.

MATERIALS

3-D flower sticker

11" × 14" (28cm × 35.5cm) canvas board

acrylic paints in black and cream

assorted patterned papers in blacks and golds

black fine-tip permanent marker

black medium-tip permanent marker

brightly colored tissue paper

brown Glimmer Mist

colored marker

decoupage medium

high-quality acrylic paints in black and medium gray

mustard chalk

rose-patterned black-and-white tissue paper

pencil

skull die cut

text-patterned paper

TOOLS

brayer

cotton swab

fine-tip paintbrush

foam brush

hole punch

scissors

TECHNIQUES

Sketching a Fashion Figure (page 10)

Facial Features and Hair (page 16)

Sketching Clothing (page 20)

Folds and Ruffles (page 26)

Putting the Figure Together (page 28)

Stamping (page 29)

Paper Collage (page 30)

Brayer (page 31)

Setting the Mood

Making this piece is the perfect excuse to whip up a delicious margarita or a glass of sangria! Here's my recipe for the perfect sangria: Place apple, orange and lemon slices, as well as some whole strawberries and grapes, into a very tall glass. Add 1 cup of white wine and ½ cup of ginger ale. A cocktail umbrella is a must!

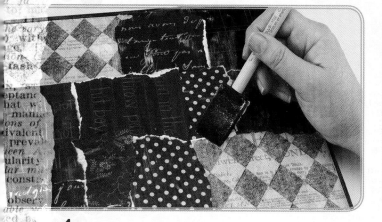

1 Paint the outer edge of a canvas board with black paint. Using the Paper Collage technique, cover the white space on the board with torn blocks of black and gold patterned paper.

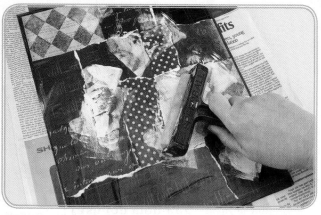

2 Using the Brayer technique, apply cream paint over the collaged paper to create a messy look. Let the paint dry.

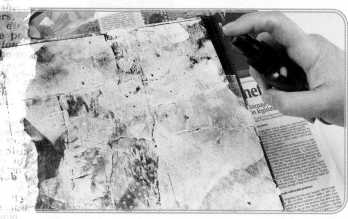

3 Thoroughly spray the board with brown Glimmer Mist. Let the canvas dry completely.

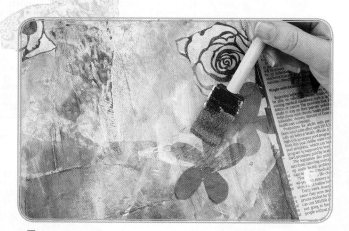

4 Cut out hand-drawn flowers from brightly colored tissue paper and roses from rose-patterned black-and-white tissue paper. Decoupage them around the edges of the board, overlapping them as desired. Let the decoupage medium dry completely.

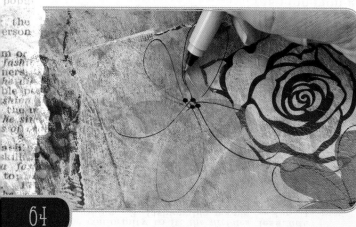

5 Draw flowers over the tissue paper flowers with a black fine-tip permanent marker. Dot the center of each flower 3 times with a black medium-tip permanent marker.

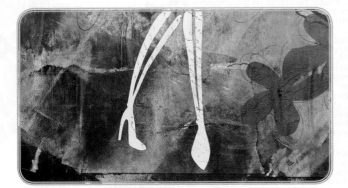

6 Sketch a skeleton figure and her dress, and trace them onto tracing paper. Use a skull die cut for the head. Use your sketch to cut out the skeleton using text-patterned paper; cut out the dress using patterned paper of your choice. Use scissors to separate the "bones" of the legs; use the image above as a guide. Use a punched paper dot for the kneecap. Apply mustard chalk to the bones with a cotton swab to make them appear aged. Decoupage the body parts to the canvas board.

7 Decoupage the girl's clothes onto the figure.

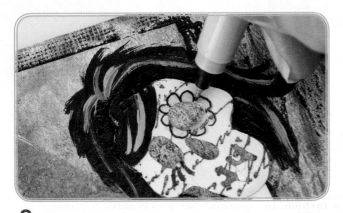

8 Using a high-quality acrylic paint and a fine-tip paintbrush, paint the hair onto the figure with black. Let the paint dry. Highlight the hair with medium gray paint. With a black fine-tip permanent marker, draw a flower around one eye and eyelashes on the other eye. Color the flower with a colored marker.

9 Cut a headband shape from tissue paper. Decoupage the headband on top of the figure's hair. Tear off 3 long, thin strips of brightly colored tissue paper. Twist each strip into a thin string, and then tightly coil the strips to form roses. Attach the roses on top of the headband with decoupage medium. Allow them to dry thoroughly.

10 Using a black fine-tip permanent marker, outline and color in the shoes. To create high-lights, leave small squiggles of the shoes uncolored. Attach a 3-D flower sticker to the girl's dress.

Apply 2 coats of decoupage medium to the entire board to seal and finish.

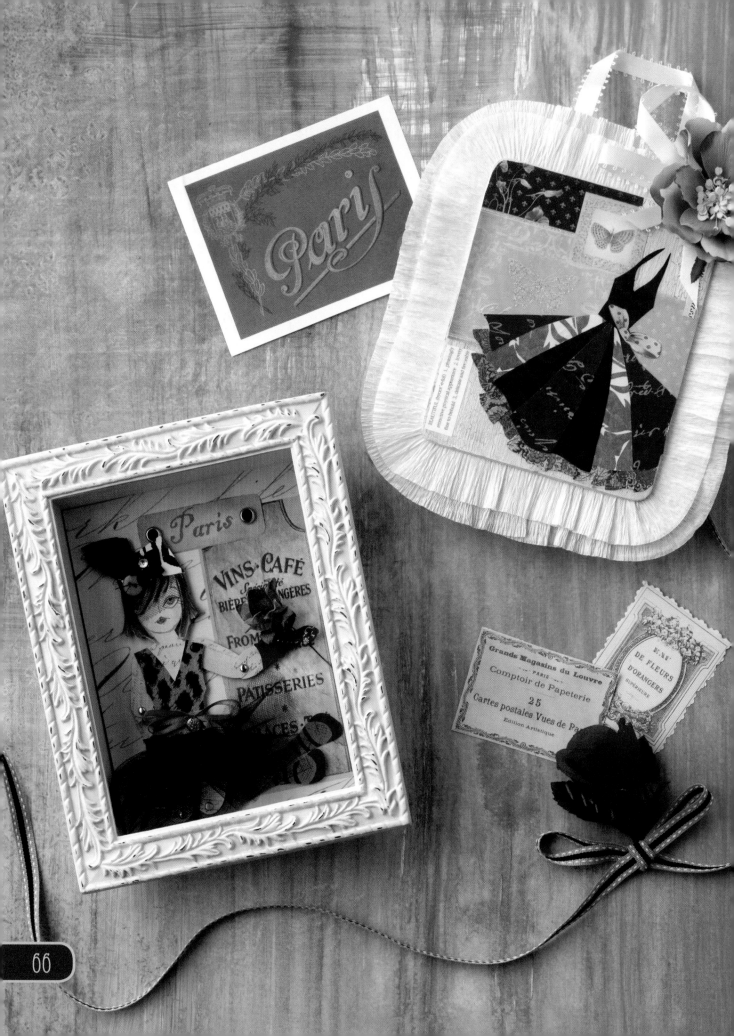

Framed FASHION

Although I typically create my art on canvas, I sometimes get the urge to do something different and less messy! The projects in this section are composed mostly of cutout papers that are simply put together with a glue stick. Because most are behind glass, using a decoupage medium is not necessary.

There are many beautiful, unusual frames to choose from. Shadow boxes are perfect for layering your collage components, and they allow you to use 3-D embellishments. Corkboards have always been a favorite of mine, because I can easily attach useful items such as recipes, jewelry and even sewing notions to the textured cork surface. The average board is less than $15, and the frame can be painted any color you like. Suddenly, you have a fabulous piece of art with a purpose!

Start perusing the frame aisles at your local craft store and see what sparks your imagination.

UN PAPILLION

Do you have a teeny-tiny space somewhere in your powder room that needs an extra-special touch? A simple plaque might be just what you're looking for. This easy, yet elegant project would also be adorable hanging in a girl's bedroom, with a child's dress instead of a lady's.

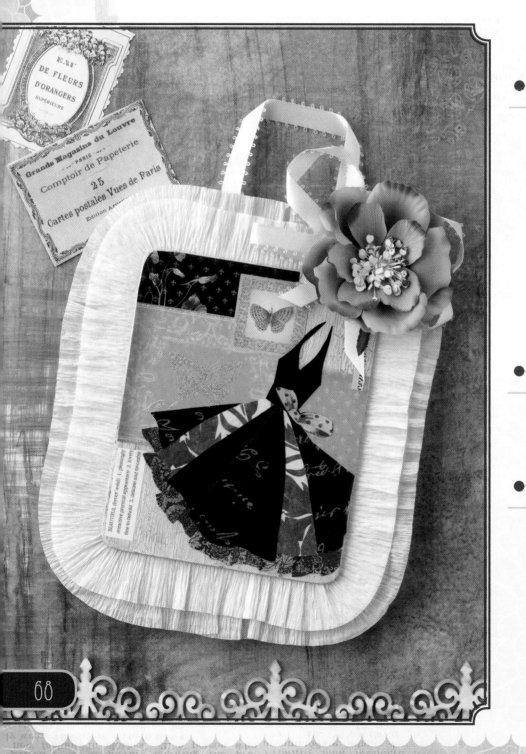

MATERIALS

5" × 6" (12.5cm × 15cm) rounded wooden plaque

acrylic paints in celery green and cream

assorted butterfly-themed patterned papers

crackle medium

crepe paper in cream and green

decoupage medium

pencil

satin ribbon

silk flower

tracing paper

TOOLS

craft glue

foam brush

scissors

TECHNIQUES

Sketching Clothing (page 20)

Folds and Ruffles (page 26)

Paper Collage (page 30)

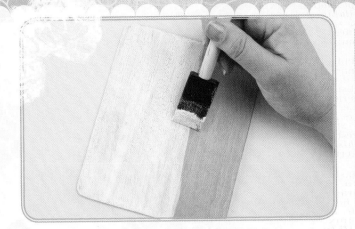

1 Paint a base coat of celery green onto a 5" × 6" (12.5cm × 15cm) rounded rectangular wooden plaque. Let the paint dry. Treat the painted board with a crackle medium and then put a coat of cream on top of it.

2 Using the Paper Collage technique, decoupage cut blocks of patterned paper onto the board. Allow some of the crackle texture to show. Trim the papers to fit the rounded corners.

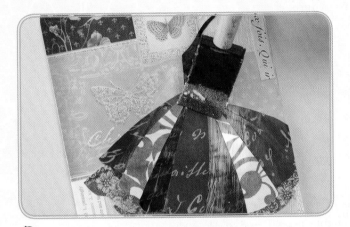

3 Draw a dress and trace it onto tracing paper. Use your sketch to cut out the dress using patterned paper of your choice. Decoupage it onto the board.

4 Cut a strip of cream crepe paper that is 1½" (4cm) wide and as long as the perimeter of the rectangle, plus 1" (2.5cm). Cut a strip of green crepe paper that is 1¾" (4.5cm) wide and as long as the cream strip. For both strips, stretch out one long edge to create a ruffle.

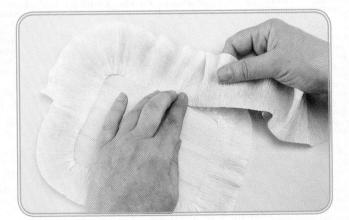

5 Glue the cream strip ½" (13mm) in from the edge of the wood, all the way around, with craft glue. Overlap the green strip on top of the cream strip and glue it down. Cut off any excess.

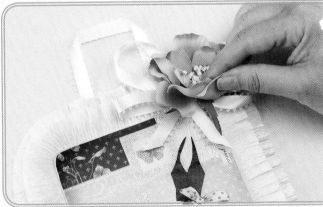

6 Attach a strip of satin ribbon to the top of the piece for hanging and a silk flower embellishment to the upper right corner with craft glue.

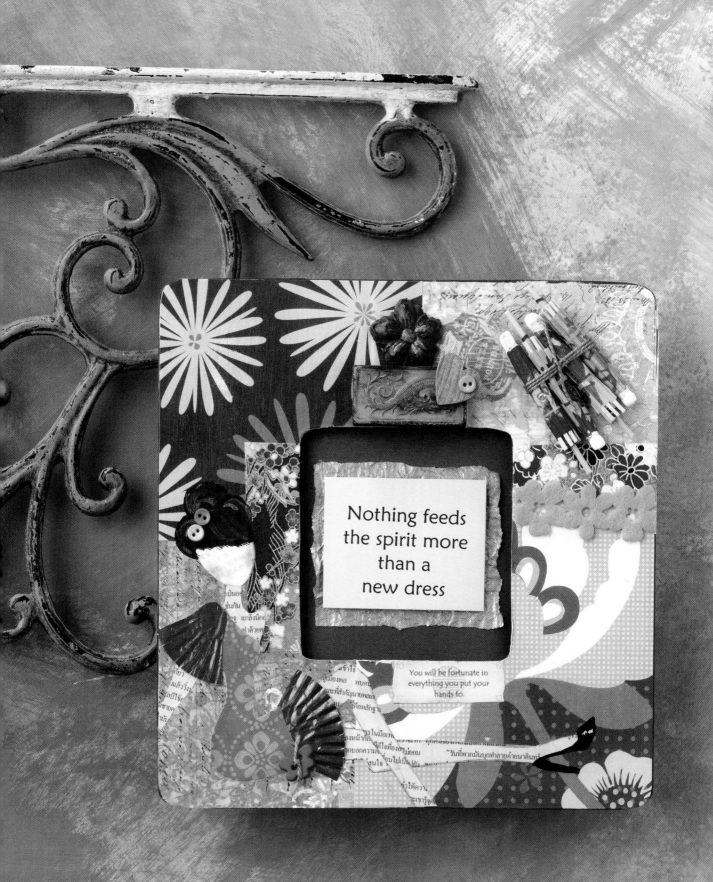

Nothing feeds
the spirit more
than a
new dress

You will be fortunate in
everything you put your
hands to.

FEEDING THE SPIRIT

One day I went shopping with my aunt, whom I sometimes refer to as my fairy godmother. I had been unemployed for some time and had drastically cut back on the lifestyle. No new clothes, no new shoes, no pedicures for a while . . . gasp! We went shopping for clothes for her, and as she was making her purchase, a jacket caught my eye and I tried it on. I loved it, but I put it back on the hanger because it was definitely not in my budget! She told the salesgirl to add it to her bill. I tried to protest, but to no avail. That jacket hung on the back of my door for three weeks just so I could look at it and savor it every day. There are times when we really need to treat ourselves, just because. That little jacket really fed my spirit at a time when I deprived myself a bit too much. I now try to treat myself more often, just because.

MATERIALS

6" × 6" (15cm × 15cm) wooden frame with a 3" × 3" (7.5cm × 7.5cm) opening

acrylic paints in metallic gold and black

assorted patterned paper

black colored pencil

black medium-tip permanent marker

buttons

cardstock in brown and cream

cocktail umbrellas

coral embroidery floss

crinkled metallic gold paper

decoupage medium

domino with dragon motif

felt floral trim

fortune from a fortune cookie

heart- and flower-shaped wooden pieces

high-quality acrylic paint in raw umber

newsprint paper

origami paper

pencil

pink chalk

small foil candy cup

tracing paper

TOOLS

3-D glue dot

cotton swab

craft glue

fine-tip and medium-tip paintbrushes

foam brush

glue stick

printer

scissors

TECHNIQUES

Sketching a Fashion Figure (page 10)

Facial Features and Hair (page 16)

Sketching Clothing (page 20)

Putting the Figure Together (page 28)

Paper Collage (page 30)

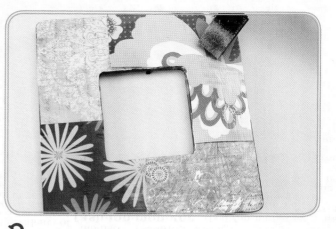

1 Paint the sides of an unfinished 6" × 6" (15cm × 15cm) wooden frame using black paint and a medium-tip paintbrush.

2 Cut out several pieces of patterned paper and origami paper to fit around the frame. Using the Paper Collage technique, decoupage these pieces onto the frame using a foam brush.

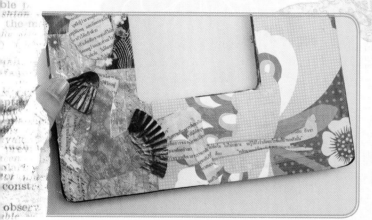

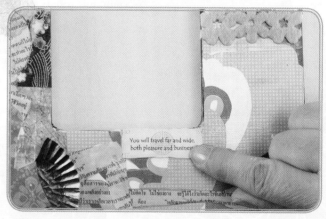

3 Sketch a figure and her dress, and trace them onto tracing paper. Use your sketch to cut out the figure using newsprint paper; cut out the dress using patterned paper of your choice. Using a black colored pencil, outline the edges of the figure's body. Decoupage the figure and dress to the bottom left of the frame. Cut sections of a small foil candy cup and adhere them to the sleeve and bottom hem of the dress to make ruffles.

4 Glue a piece of felt floral trim across the right side of the frame. Glue a fortune from a fortune cookie to the bottom of the frame.

5 Using a high-quality acrylic paint and a fine-tip paintbrush, paint the hair onto the figure with raw umber. Let the paint dry. Highlight the hair with metallic gold paint. Use pink chalk and a cotton swab to highlight the cheeks on the figure's face.

6 Using a black medium-tip permanent marker, outline and then color in the shoes. To create highlights, leave small squiggles of the shoes uncolored.

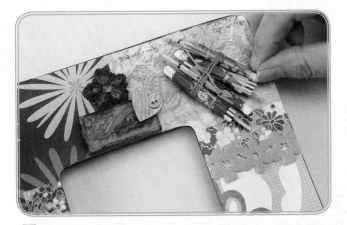

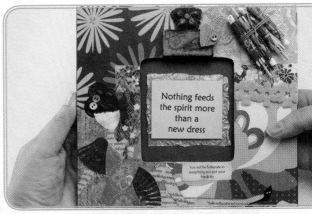

Nothing feeds
the spirit more
than a
new dress

7 Using craft glue, adhere buttons to the girl's hair. Using coral embroidery floss, tie cocktail umbrellas together and glue them to the upper right corner of the frame. Glue a domino with a dragon motif to the top of the frame. Paint heart- and flower-shaped wooden pieces with black and metallic gold and glue them to the top of the domino.

8 Cut a piece of brown cardstock to fit the inside of the frame. Glue a smaller piece of metallic gold crinkled paper to the center of the cardstock with a glue stick. Print a quote onto cream cardstock and cut it out. Glue the quote on top of the gold paper with a 3-D glue dot. Fit the quote inside the frame and fasten the frame tabs.

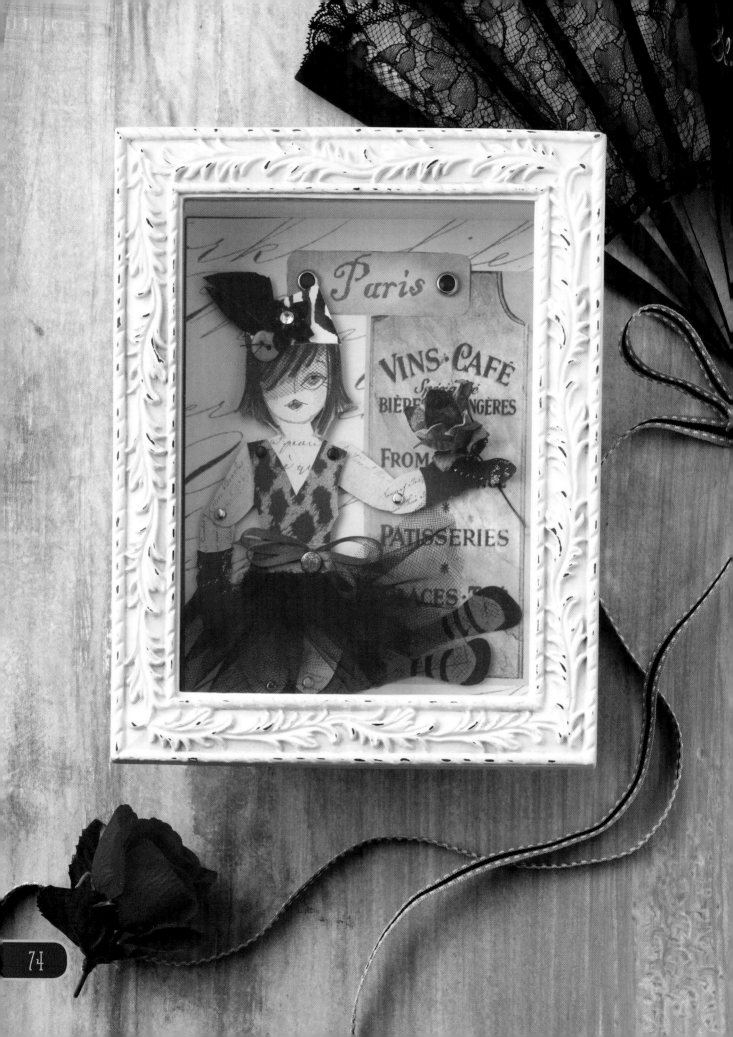

MOULIN ROUGE

Like a lot of you, I am always on the hunt for inexpensive treasures. I found bunches of small shadow-box frames on a clearance table at a major department store years ago. They cost next to nothing and had the saddest looking floral bouquets in them. Out went the flowers and in went a dainty French dancer with fishnet stockings and posable joints. A tutu made of tulle was the perfect finishing touch.

MATERIALS

⅛" (3mm) wide coral satin ribbon

5" × 7" (12.5cm × 18cm) vintage-style shadow-box frame

black feather

black fine-tip permanent marker

black satin bow with rhinestone center

black thread

black tulle

brown artist markers in various tones

cardstock in black and white

colored pencils

French-themed paper collage elements

gold glitter glue

large decorative brads

leopard-print, zebra-print and text-patterned cardstock

pink button

rhinestone brad

script-patterned paper

silk rose

small brads

templates (page 79)

TOOLS

⅛" (3mm) hole punch

3-D glue dots

craft glue

glue stick

scissors

sewing needle

TECHNIQUES

Facial Features and Hair (page 16)

Setting the Mood

Go to Paris for the day! Yes, you heard me right. Splurge on a book that features gorgeous photos of the romantic city. This will get your mind in the place where it needs to be to design great clothes!

1 Cut a piece of script-patterned paper measuring 5" × 7" (12.5cm × 18cm). Glue this piece of paper into the back of a 5" × 7" (12.5cm × 18cm) shadow box.

2 Cut out 2 French-themed paper collage elements. Punch holes in them and connect them with large decorative brads. Glue the elements on top of the script-patterned paper with a glue stick.

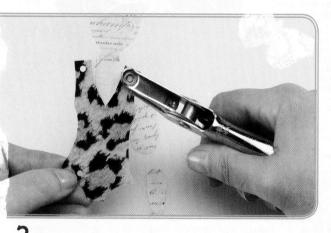

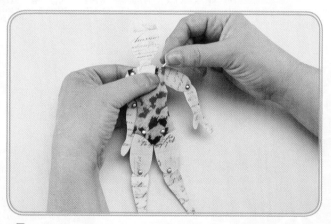

3 Using the templates on page 79, cut out the doll parts from text-patterned cardstock. Cut out the figure's outfit using leopard-print cardstock and glue it over the body. Punch ⅛" (3mm) holes into the doll parts as directed by the templates.

4 Assemble the body by connecting the pieces with small brads.

Tip

When adding an outfit over a figure's body, trim any excess from the body so it doesn't show from behind the outfit.

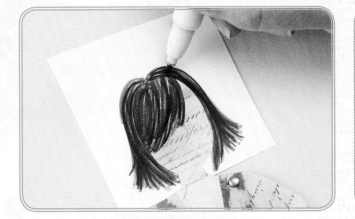

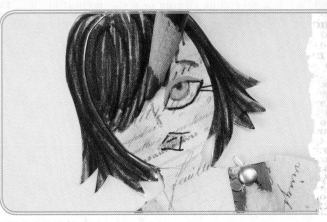

5 Cut a square of white cardstock and glue it behind the doll's head. Using brown artist markers in various tones, begin drawing the hair around the head onto the white cardstock. Draw the bangs onto the doll head as well. Trim the remaining white cardstock from the head.

6 Draw a face onto the paper doll with colored pencils and a black fine-tip permanent marker. I drew only one eye since the other eye is hidden by bangs.

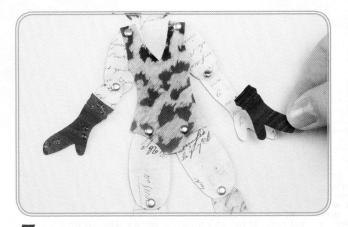

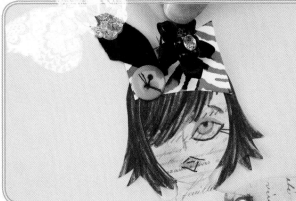

7 Cut 2 gloves from black cardstock using the template. Embellish them with gold glitter glue. Glue the gloves to the doll's hands.

8 Cut a hat from zebra-print cardstock using the template. Using craft glue, adhere a ¾" (2cm) black feather and a pink button threaded with black thread to the hat. Adhere a black satin bow with a rhinestone center to the hat with a 3-D glue dot.

Tip

If you can't find tiny black feathers, snip the tip of a large black feather, which can be found in most craft stores.

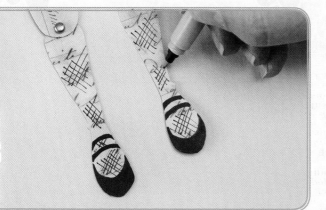

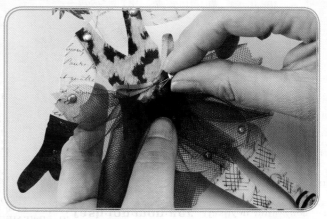

9 Using a black fine-tip permanent marker, outline and then color in the shoes. Draw fishnet stockings onto the doll's legs.

10 Cut a 3" × 12" (7.5cm × 30.5cm) piece of black tulle and fold it in half widthwise. Sew a gathering stitch on the folded edge to create a tutu. Glue the tutu around the waist of the doll with 3-D glue dots. Tie a piece of 1/8" (3mm) wide coral satin ribbon into a bow and glue it to the edge of the tutu. Punch a hole in the girl just below the ribbon and attach a rhinestone brad through this hole.

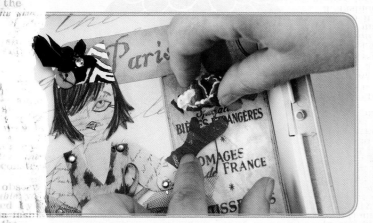

11 Position the paper doll in the bottom of the shadow box, bending the limbs until you are satisfied with her pose. In my shadow box, the doll is on her knees, with one arm extended and the other behind her back. Glue the doll into the box with glue dots. Glue a silk rose into her extended hand with a glue dot. Reassemble the shadow-box frame.

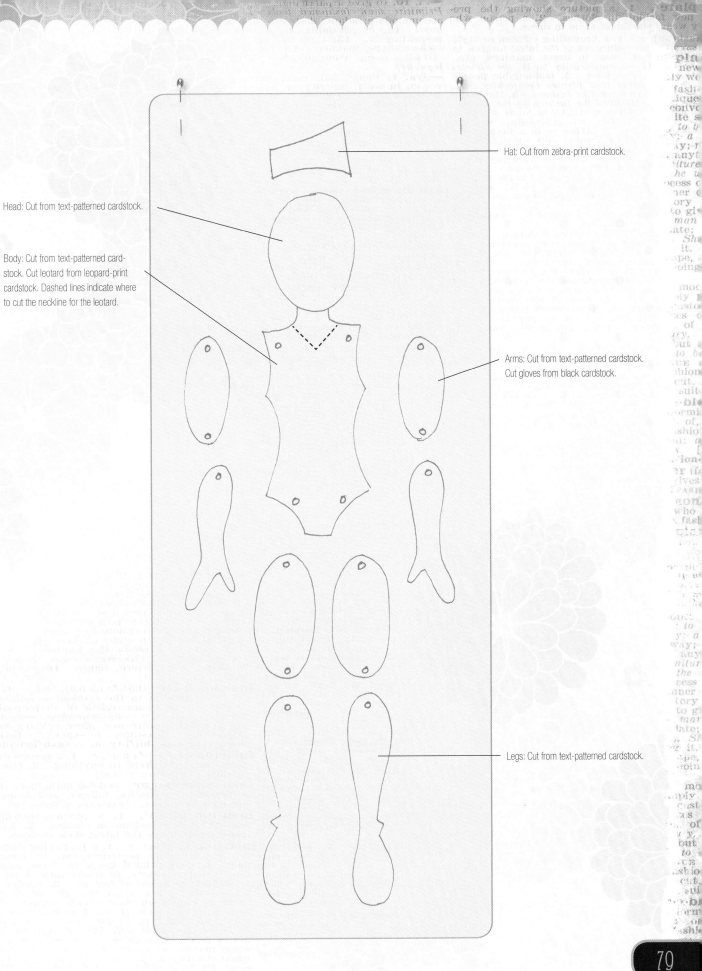

Hat: Cut from zebra-print cardstock.

Head: Cut from text-patterned cardstock.

Body: Cut from text-patterned card-stock. Cut leotard from leopard-print cardstock. Dashed lines indicate where to cut the neckline for the leotard.

Arms: Cut from text-patterned cardstock. Cut gloves from black cardstock.

Legs: Cut from text-patterned cardstock.

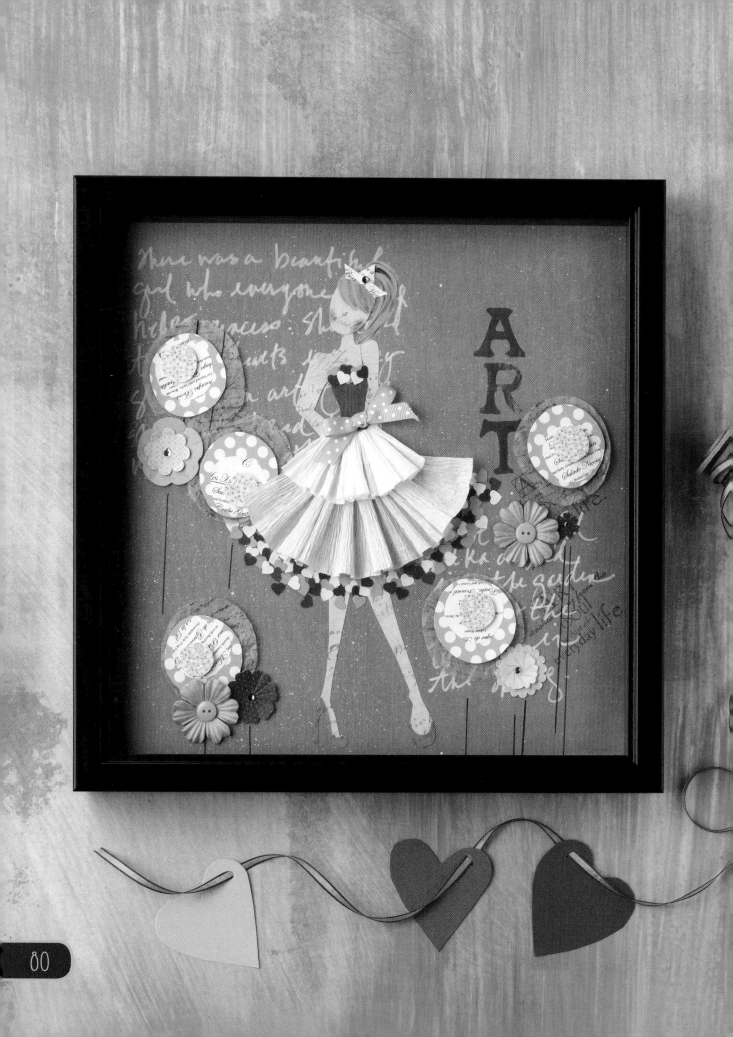

PRINCESS OF HEARTS

Crepe paper was a staple in my craft world when I was growing up, and I love that it has come back with a vengeance! It's perfect for crisp, feminine petticoats. Punched hearts give the look of airy ruffles billowing out from under the ruffles, creating a rather soft, girly piece of art.

MATERIALS

¼" (6mm) wide green polka dot ribbon

12" × 12" (30.5cm × 30.5cm) shadow-box frame

12" × 12" (30.5cm × 30.5cm) natural brown cardstock

assorted patterned papers in pink, blue and other desired colors

acrylic paint in dark brown

brown colored marker

brown tissue paper

buttons

crepe paper in green and white

dark brown ink

die-cut flowers

different shades of pink cardstock

high-quality acrylic paints in golden yellow and burnt sienna

pencil

pink chalk

pink ink

pink medium-tip permanent marker

script-patterned paper

self-adhesive rhinestones

silk flowers

tracing paper

white marker

TOOLS

3-D glue dots

alphabet stamps

cotton swab

craft glue

fine-tip paintbrush

French-script stamp

glue stick

heavy object or paperweight

large rose stamp

quote stamp

scissors

small heart punch

straightedge

TECHNIQUES

Sketching a Fashion Figure (page 10)

Facial Features and Hair (page 16)

Sketching Clothing (page 20)

Putting the Figure Together (page 28)

Stamping (page 29)

Setting the Mood

Get in the mood to create a princess! I wore a sparkly tiara while creating this piece. A word of warning: be sure to take it off before you answer the door! Yes, it's a teeny bit embarrassing to accept a package in your pj's and a tiara!

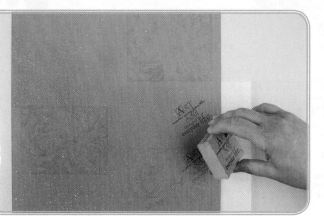

1 Stamp a 12" × 12" (30.5cm × 30.5cm) sheet of natural brown cardstock with a large rose stamp and pink ink. Stamp the right side of the cardstock again once with a quote stamp and dark brown ink. Journal quotes or passages in various places on the cardstock with a white marker.

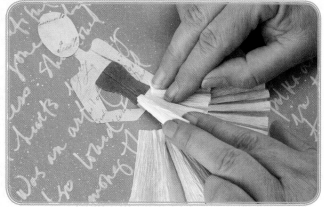

2 Sketch a figure and her bodice, and trace them onto tracing paper. Use your sketch to cut out the figure using script-patterned paper; cut out the bodice using patterned paper of your choice.

Cut a 2" × 8" (5cm × 20.5cm) strip of green crepe paper and a 1½" × 6" (4cm × 15cm) strip of white crepe paper. Stretch one long edge of each strip to create a ruffle and gather the other side, securing it with craft glue. Place a heavy object or a paperweight over this edge until the glue dries. Glue the figure and her bodice onto the background. Glue the green crepe paper strip just above the legs, leaving ½" (13mm) of space in between. Layer the white strip on top of the green so it ends at the waist.

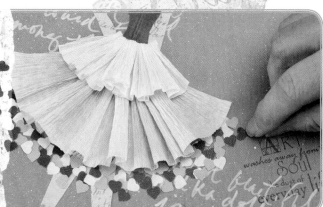

3 Punch out tiny hearts from different shades of pink cardstock. Adhere a ruffle of hearts at the bottom of the skirt. Accent the top of the bodice with another cluster of hearts.

4 Using a high-quality acrylic paint and a fine-tip paintbrush, paint the hair onto the figure with golden yellow. Let the paint dry. Highlight the hair with burnt sienna. Cut out a crown shape from script-patterned paper and glue it over the figure's hair. Use pink chalk and a cotton swab to highlight the cheeks on the figure's face.

5 Using a pink permanent marker, outline and then color in the shoes. To create highlights, leave small squiggles of the shoes uncolored.

6 Using the Stamping technique, stamp the letters A, R and T to the right of the figure in dark brown paint.

7 Cut 4 circles: a large brown tissue-paper circle that is crinkled and stamped with a French-script stamp and brown ink; a slightly smaller pink patterned paper circle; a slightly smaller script-patterned paper circle; and a tiny blue patterned paper circle. Glue the circles together, layering them so the smallest circle is on top. Adhere the blue circle with a 3-D glue dot. Repeat this step 4 more times. Glue the circle elements to the background as desired, gluing only the centers so the tissue paper is still fluffed at the edges.

8 Glue die-cut flowers and silk flowers to the piece with a glue stick. Draw stems using a straightedge and a brown marker.

9 Adhere self-adhesive rhinestones to the crepe paper ruffles on the dress, the crown and some of the flower centers. Glue buttons onto some of the flower centers. Tie a ¼" (6mm) wide green polka dot ribbon into a bow and glue it to the figure's waist.

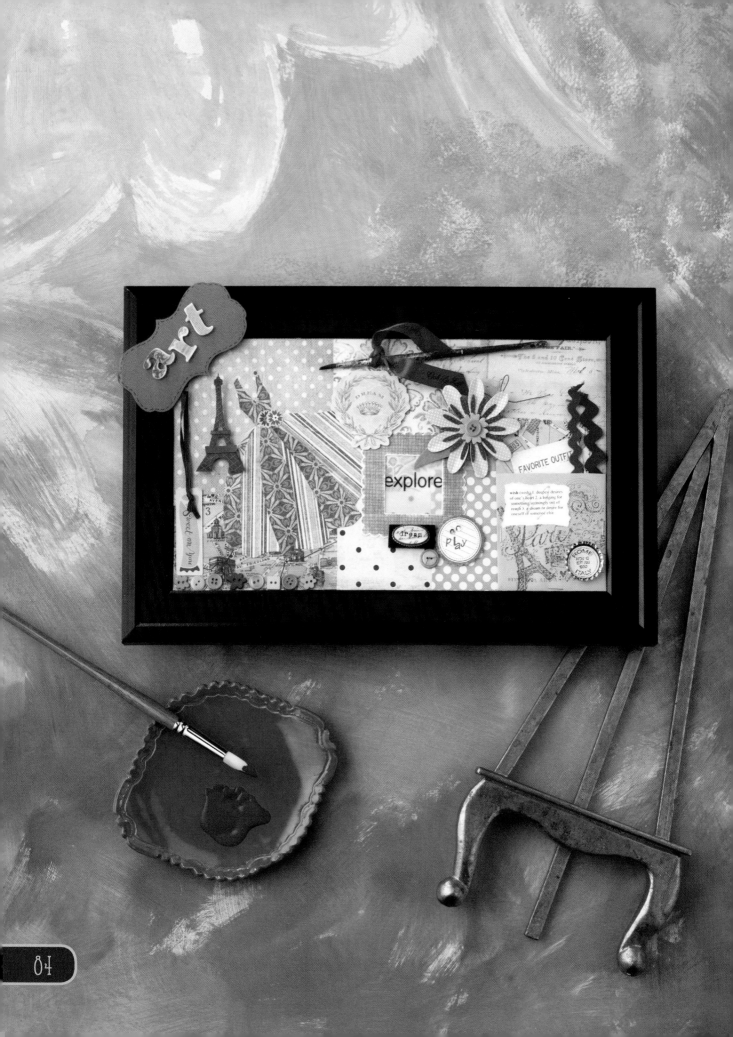

PARISIAN INSPIRATION

I think everyone needs a little inspiration board hanging in their art space revealing the things they love most. I love color, clothes and travel, and created this corkboard to tell my story. It's a wonderful piece that I can add to whenever I want.

I suggest that you journal about your own inspirations before starting this project. Perhaps your love of cooking will inspire you to collage family recipes on the board. Or maybe you love sewing; vintage button cards and trims would look wonderful on a backdrop of "quilted" papers.

MATERIALS

11" × 17" (28cm × 43cm) framed corkboard

assorted patterned paper

black fine-tip permanent marker

bottlecap

brown ink

buttons

chipboard letters

decoupage medium

die-cut flowers

die-cut leaf

French-themed die-cuts

green floral wire

library pocket

old paintbrush

pencil

pink glitter glue

pink ink

red cardstock

ribbon

rickrack trim

self-adhesive rhinestones

square die-cut frame

tags

tickets

tracing paper

typing paper

vellum square with a word or phrase

vintage collage elements

TOOLS

3-D glue dots

airmail stamp

alphabet stamps

craft glue

foam brush

Paris text stamp

printer

scissors

stapler

TECHNIQUES

Sketching Clothing (page 20)

Folds and Ruffles (page 26)

Paper Collage (page 30)

1 Spread a coat of decoupage medium over the entire surface of an 11" × 17" (28cm × 43cm) corkboard frame and let it dry; this makes the surface stickier for the paper. Decoupage several different blocks of patterned paper onto the corkboard, leaving the bottom right corner exposed.

2 Stamp a library pocket with a Paris text stamp and brown ink and an airmail stamp and pink ink. Staple the pocket onto the exposed corner of the corkboard close to the frame.

Tip

If the decoupage medium accidentally gets on the frame, don't worry. Let it dry, and then peel it off.

3 Print out the definition of the word *wish* onto typing paper and tear it out. Glue this piece to the library pocket and squiggle some pink glitter glue on top of it. Fill the library pocket with rickrack trim, tags and tickets with the word *wish* written on them.

4 Layer 3 different size die-cut flowers from largest to smallest. Glue a die-cut leaf behind the largest flower. Thread a piece of green floral wire through the flower layers from large to small. Thread on a button. Thread the wire back down through the second hole in the button and back through all 3 flowers. Twist the wire on the other side to secure. Coil the stem once with your hands and insert the flower into the library pocket.

5 Sketch a dress and trace it onto tracing paper. Use your sketch to cut out the dress using patterned paper of your choice. Decoupage the dress on the left side of the corkboard. Add 2 die-cut flowers to the waist of the dress.

6 Cut a vellum square with a word or phrase on it to fit behind a square die-cut frame. Glue the frame to the vellum, and then glue the element to the collage. Embellish 2 vintage collage elements with rhinestones and alphabet stamps. Glue them on opposite corners of the frame, using a 3-D glue dot to glue one of them.

7 Add embellishments to personalize the piece. I added an old paintbrush with ribbon tied around it, tags, buttons, a bottlecap and various French-themed die-cuts to my piece.

8 Cut a scrollwork shape from red cardstock that is large enough to hold the chipboard letters A, R and T. Draw dashes in a border around the form with a black fine-tip permanent marker. Adhere the chipboard letters to the shape and glue the element in the upper right corner of the board, directly on the frame.

AUBERGINE DREAM

For this project, I was inspired by a complete paper line. I loved the colors, I loved the patterns, and I just had to use them all together! I did add an odd pattern to the mix so it wasn't so collectiony. I found the shadow-box frame at the craft store and thought the plain matting could be transformed into something fabulous with paper.

MATERIALS

8" × 10" (20.5cm × 25.5cm) light brown cardstock

8" × 10" (20.5cm × 25.5cm) script-patterned paper

12" × 14" (30.5cm × 35.5cm) shadow-box frame with an 8" × 10" (20.5cm × 25.5cm) opening

assorted patterned paper

brown chalk

brown ink

dark purple cardstock

floral-patterned paper

pencil

purple silk or organdy ribbon

ribbon embellishment

tracing paper

vintage collage elements, including a bird, leaf and seashell

wrinkled gold art paper

TOOLS

3-D glue dots

alphabet stamps

craft glue

glue stick

scissors

TECHNIQUES

Sketching Clothing (page 20)

Folds and Ruffles (page 26)

1 Tear an 8" × 10" (20.5cm × 25.5cm) piece of script-patterned paper in half lengthwise. Glue this to the right side of an 8" × 10" (20.5cm × 25.5cm) piece of brown cardstock. Glue a smaller square of floral-patterned paper and a paper leaf to the background.

2 Sketch a dress and trace it onto tracing paper. Cut out the dress using patterned paper of your choice. Glue the dress pieces together with a glue stick.

3 Place the dress where you would like it in the collage, but don't glue it down. Cut pieces of wrinkled gold art paper to fit at the bottom of the dress for the ruffle. Glue the ruffle down, but don't press the pieces completely flat; leave some puffiness intact to add to the ruffled look. Remove the dress after the ruffle is complete.

4 Chalk the edges of a vintage collage element with brown chalk. Stamp the word *dream* with alphabet stamps and brown ink. Glue the element to the collage above the square of floral-patterned paper.

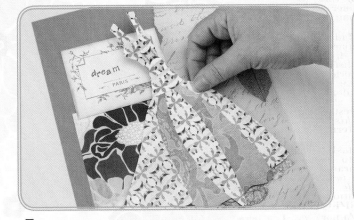

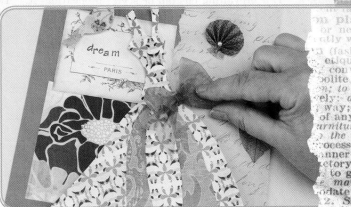

5 Adhere the dress to the collage with 3-D glue dots.

6 Add vintage collage elements, such as a bird, a leaf and a seashell, to the collage as desired. Use 3-D glue dots to adhere a few of them for added dimension. Tie a piece of purple silk or organdy ribbon into a bow and glue it to the waist of the dress.

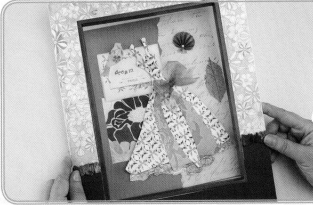

7 Cut a piece of patterned paper and a piece of dark purple cardstock to fit the matte inset of the shadow box. Glue them to the inset. Where the pieces meet, glue pieces of ribbon embellishment.

8 Apply craft glue to the back of the inset and glue it over the collage. Reassemble the shadow box with the collage inside.

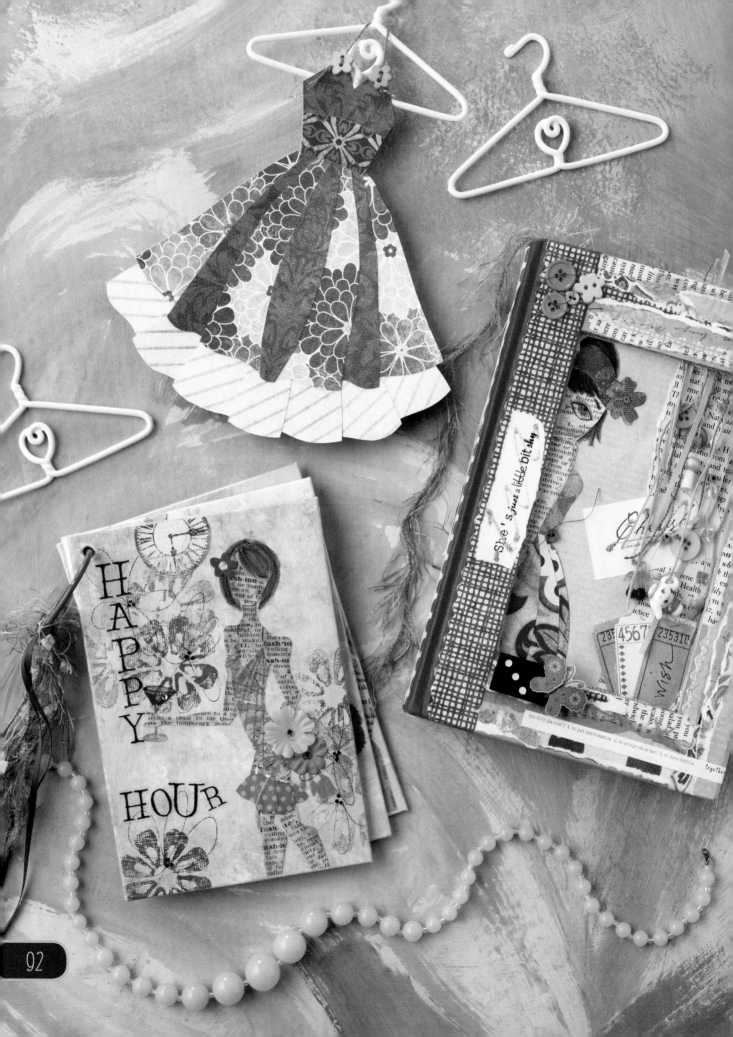

Fashionable GIFTS

The projects in this chapter focus on fun items that you can give as gifts or keep for yourself. Some are quick and easy, while others, such as the books, are a bit more involved. All can be personalized to the recipient, using her hair color, style preferences and even her favorite colors. Journaling sweet messages to the recipient on any of these projects would be a nice touch.

These projects make a special occasion even more special. From a set of paper dolls for a little one to a recipe book for a bride-to-be, collaged gifts are fun to make and even more fun to give.

DRESS IT UP

I came across these doll-sized hangers in my supplies a couple of years ago and thought they'd be cute with paper dresses on them. I made dresses using holiday-themed paper, copied them with a color copier and used them to embellish my girlfriends' Christmas gifts. To my surprise, one of my friends used hers on a wreath the following year. See what ideas you can come up with!

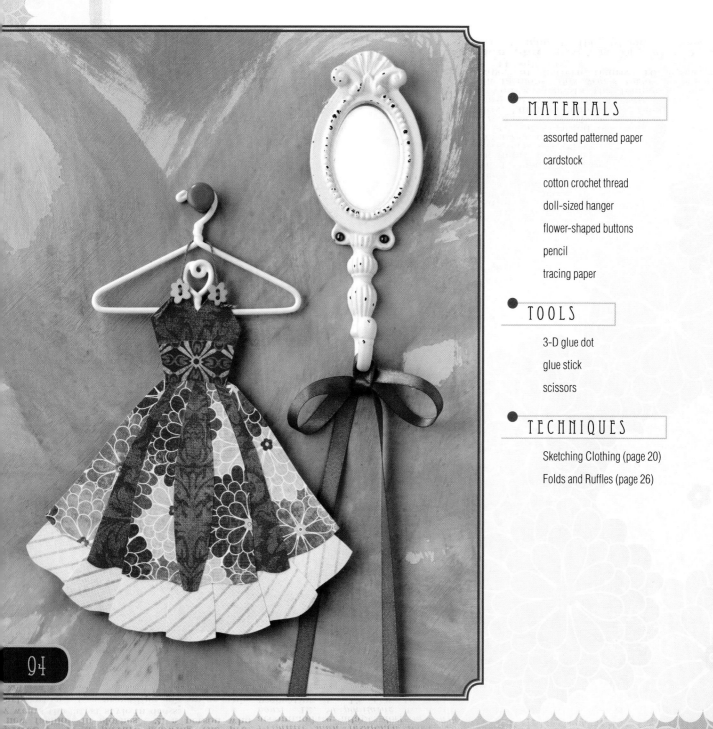

MATERIALS

assorted patterned paper

cardstock

cotton crochet thread

doll-sized hanger

flower-shaped buttons

pencil

tracing paper

TOOLS

3-D glue dot

glue stick

scissors

TECHNIQUES

Sketching Clothing (page 20)

Folds and Ruffles (page 26)

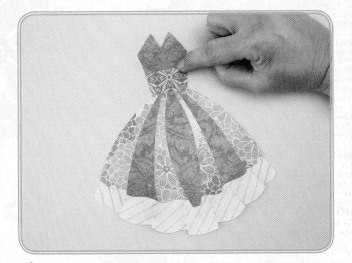

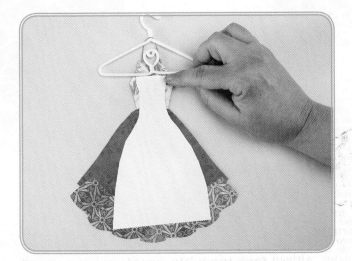

1 Sketch a dress and trace it onto tracing paper. Use your sketch to cut out the dress using patterned paper of your choice. Assemble the dress pieces with a glue stick.

2 Tie flower-shaped buttons to both ends of a small piece of cotton crochet thread and attach the buttons to the straps on the dress. Hang the thread around a doll-sized hanger.

3 Flip the dress over. Cut a piece of cardstock to fit behind the dress and act as a stabilizer. Glue it to the back of the dress. Add a 3-D glue dot to the back of the dress so it will stick to the hanger.

MEET VERONIQUE AND ANTOINETTE

Once made, these adorable friends can be copied on a color copier and made into bookmarks or package embellishments. I even reduced some and used them as cupcake toppers. If you have a fair amount of time, make several different girls and string them with ribbon to make a party banner. Their uses are endless!

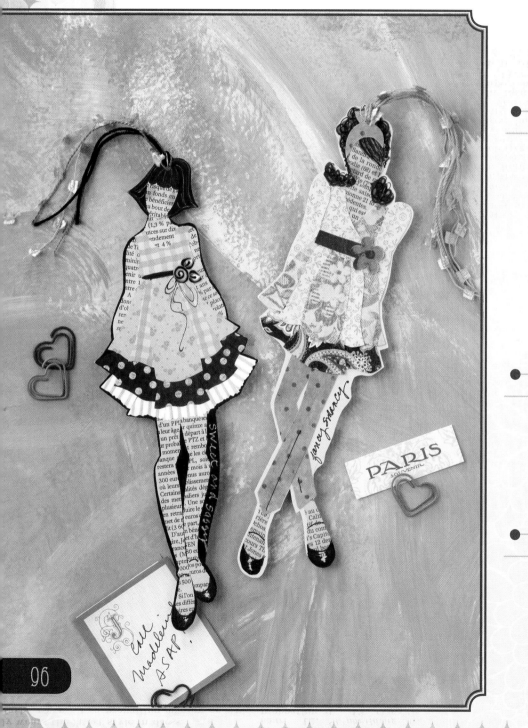

MATERIALS

8½" × 11" (21.5cm × 28cm) cardstock in white and desired color

assorted patterned paper

black fine-tip permanent marker

brown artist markers in various tones

newsprint paper

pencil

pink chalk

ribbon and yarn

tracing paper

TOOLS

color copier

cotton swab

glue stick

hole punch

scissors

TECHNIQUES

Sketching a Fashion Figure (page 10)

Facial Features and Hair (page 16)

Sketching Clothing (page 20)

Folds and Ruffles (page 26)

Putting the Figure Together (page 28)

1 Sketch a figure and her outfit, and trace them onto tracing paper. Use your sketch to cut out the figure using newsprint paper; cut out the outfit using patterned paper of your choice. Using a glue stick, adhere the pieces onto an 8½" × 11" (21.5cm × 28cm) piece of cardstock.

2 Draw in the figure's hair with brown artist markers in various tones. Cut out a headband and glue it over the hair. Pink the cheeks with a cotton swab and pink chalk. Use a black fine-tip permanent marker to make a few lines as accents on the leggings.

3 Draw and color in the shoes with a black fine-tip permanent marker. To create highlights, leave small squiggles of the shoes uncolored.

Along the side of the figure, write a phrase; for this bookmark, I wrote *fancy schmancy*.

4 Copy and print the doll onto white cardstock using a color copier. Cut the bookmark out. Punch a small hole at the top and fasten on strands of ribbon and yarn. Trim the ends.

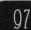

AMELIE PLAYS DRESS-UP

What little girl wouldn't want a set of adorable paper dolls? I used to love playing with paper dolls as a girl, and I still love making them. I don't think playing dress-up ever gets out of our systems. Make several copies of a doll and her outfits as party favors, and if you're feeling especially ambitious, match hair and skin tones to the recipients. Reduced, a dressed doll would make a darling cupcake topper!

MATERIALS

8½" × 11" (21.5cm × 28cm) cardstock in brown, pink and white

assorted patterned paper

black fine-tip permanent marker

black medium-tip permanent marker

black ink

brown artist markers in various tones

buttons

pencil

pink chalk

thread

tracing paper

TOOLS

color copier

cotton swab

glue stick

French-script stamp

scissors

TECHNIQUES

Sketching a Fashion Figure (page 10)

Facial Features and Hair (page 16)

Sketching Clothing (page 20)

Folds and Ruffles (page 26)

Putting the Figure Together (page 28)

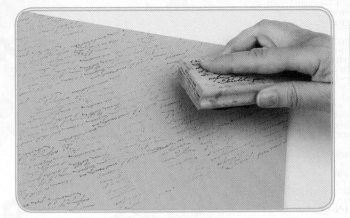

1 Stamp an 8½" × 11" (21.5cm × 28cm) piece of brown cardstock with a French-script stamp and black ink. Sketch a figure and several outfits, including undergarments, separately, and trace them onto tracing paper. Use your sketches to cut out the figure using the French-script-stamped paper; cut out the outfits using patterned paper of your choice.

2 Draw and color in the figure's shoes with a black medium-tip permanent marker. To create highlights, leave small squiggles of the shoes uncolored.

3 Glue the figure to the left side of an 8½" × 11" (21.5cm × 28cm) piece of pink cardstock. Glue on the figure's undergarments.

4 Draw the figure's hair with brown artist markers in various tones. Use pink chalk and a cotton swab to highlight the cheeks on the figure's face.

5 Assemble the outfits with a glue stick and adhere them to the pink piece of cardstock. Write quotes and definitions onto cardstock, cut them out and glue them to the page as embellishments. Draw tabs onto each outfit with a black fine-tip permanent marker.

6 Tie small pieces of thread to buttons and glue them to the cardstock. Copy and print the sheet onto an 8½" × 11" (21.5cm × 28cm) piece of white cardstock using a color copier.

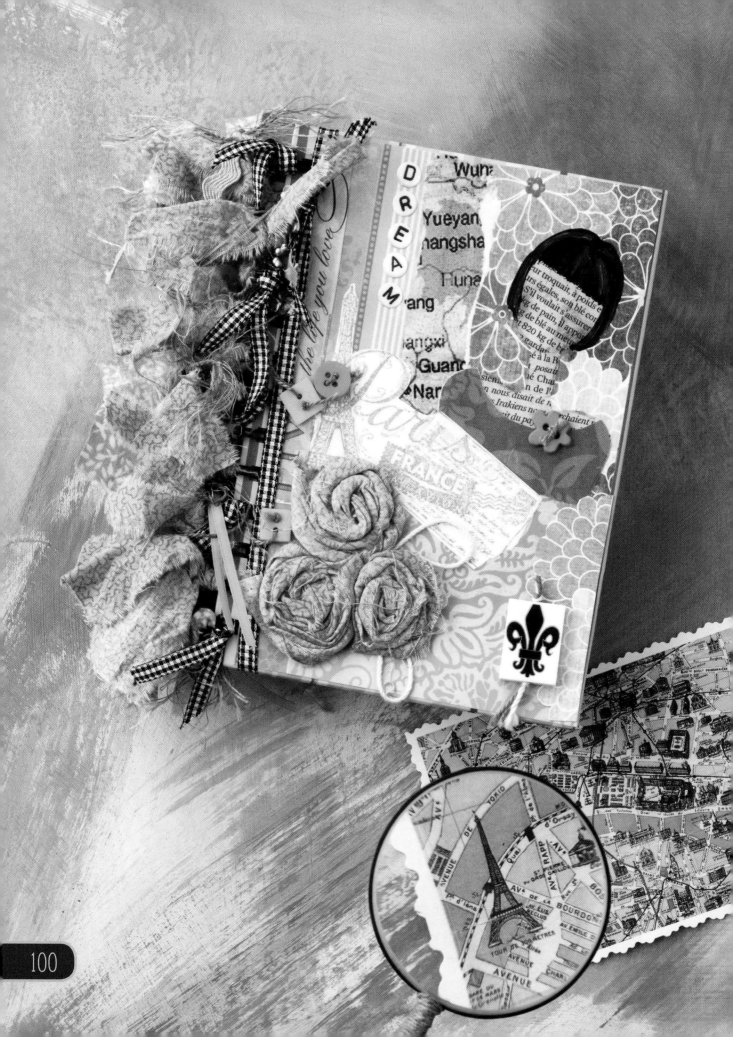

PARISIAN DREAMS

I pick up small spiral journals all the time in the dollar section of my local craft store. Usually they have pretty pages inside, and the outsides are cute enough that I don't have to embellish the backs at all. I make a few journals at a time in different color combinations so I always have a last-minute gift handy when I need it. What girl wouldn't love a sweet notepad to journal her dreams in?

MATERIALS

- acrylic paint in metallic bronze
- assorted patterned paper
- black colored pencil
- buttons, ceramic charms and alphabet beads
- cotton crochet thread or embroidery floss
- decorative tags and die cuts
- decoupage medium
- fabric and ribbon scraps
- high-quality acrylic paint in raw umber
- newsprint paper
- pencil
- pink chalk
- pink ink
- pink thread
- sewing thread
- spiral-bound journal
- tracing paper
- vellum envelope
- white cardstock

TOOLS

- cotton swab
- craft glue
- fine-tip paintbrush
- foam brush
- glue stick
- Paris-themed stamp
- scissors
- scrollwork stamp
- sewing needle

TECHNIQUES

- Sketching a Fashion Figure (page 10)
- Facial Features and Hair (page 16)
- Sketching Clothing (page 20)
- Putting the Figure Together (page 28)
- Paper Collage (page 30)

1 Using the Paper Collage technique, decoupage torn pieces of patterned paper onto a spiral-bound journal cover. The cover I used has a striped design, but you can also use a cover in a solid color.

2 Sketch the head and shirt of a figure, and trace them onto tracing paper. Use your sketch to cut out the figure using newsprint paper; cut out the shirt using patterned paper of your choice. Using a black colored pencil, outline the edges of the figure's head and body. Decoupage the pieces onto the upper right corner of the journal cover.

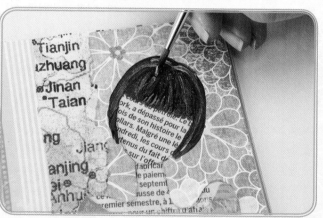

3 Stamp a piece of white cardstock with a Paris-themed stamp and a scrollwork stamp using pink ink. Cut out a portion of the stamped image and adhere it to the journal with decoupage medium over the figure's body.

4 Using a high-quality acrylic paint and a fine-tip paintbrush, paint the hair onto the figure with raw umber. Let the paint dry. Highlight the hair with metallic bronze paint. Use pink chalk and a cotton swab to highlight the cheeks on the figure's face.

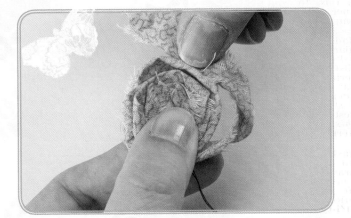

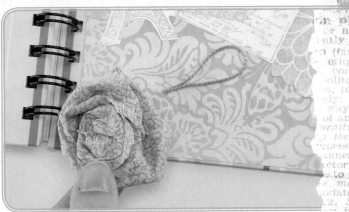

5 Make fabric flowers by cutting ½" (13mm) wide strips of fabric into 18" (45.5cm) long pieces. Fray the edges of the strips with your fingertips. Begin coiling a strip at one end, twisting the fabric as you coil. After every few coils, secure the coil by sewing through the layers with sewing thread. Make 3 fabric flowers.

6 Glue the 3 flowers in the lower left corner of the journal. Glue small loops of cotton crochet thread or embroidery floss extending from the flowers.

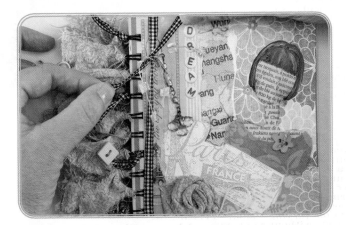

7 Add 3-D embellishments, such as scraps of ribbon and fabric, buttons, ceramic charms and alphabet beads, to the cover. I spelled out the word *dream* with alphabet beads and glued a button threaded with pink thread to the figure's shirt.

8 Glue a vellum envelope to the inside of the journal cover with a glue stick. Insert decorative tags, die cuts and ribbons into the envelope.

Tip

I often give these journals as gifts. Make sure to decoupage torn paper or glue an embellishment over the bar code on the back of a purchased journal.

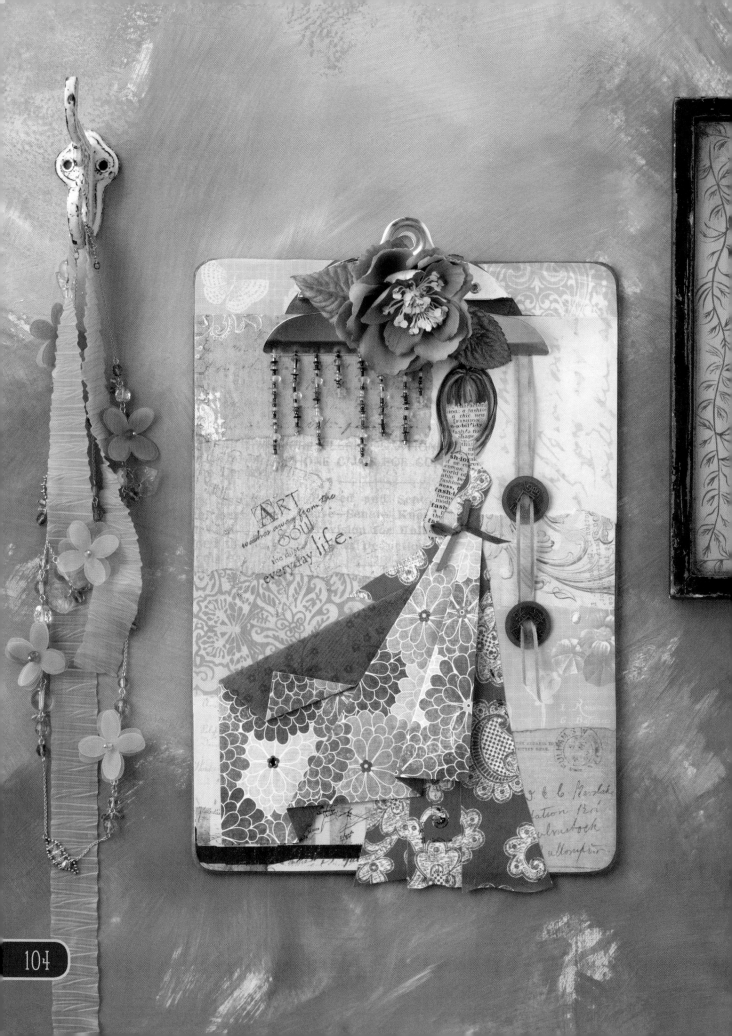

JAPANESE GARDEN

Since I was young, I have always adored origami. Perhaps it's because I grew up in northern California, where Japanese gardens are the norm. There are always quaint little gift shops that sell origami kits, sweet wooden dolls and teapots galore. These are some of my favorite things, so it seemed natural to come up with a gorgeous folded gown for the figure in this project.

MATERIALS

acrylic paint in metallic gold

Asian-themed coins

assorted patterned paper, including text-patterned paper

beaded ribbon

brown ink

chalk in pink and brown

decoupage medium

high-quality acrylic paint in burnt umber

pencil

pink glitter glue

ribbon

self-adhesive rhinestones

silk flower

standard-sized clipboard

tracing paper

TOOLS

cotton swabs

craft glue

craft knife

fine-tip paintbrush

foam brush

glue stick

paper clip

quote stamp

scissors

straightedge

TECHNIQUES

Sketching a Fashion Figure (page 10)

Facial Features and Hair (page 16)

Sketching Clothing (page 20)

Putting the Figure Together (page 28)

Paper Collage (page 30)

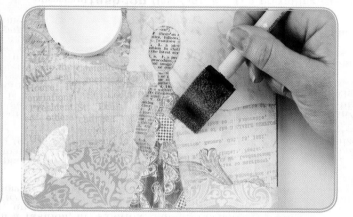

1 Using the Paper Collage technique, cover the surface of a standard-sized clipboard with torn pieces of patterned paper. If the corners of your clipboard are rounded, trim the paper around the corners to fit.

2 Sketch the figure and her dress, and trace them onto tracing paper. Use your sketch to cut out the figure using text-patterned paper; cut out the dress pieces using patterned paper of your choice. Using a cotton swab, apply brown chalk to the edges of the figure. Decoupage the pieces to the clipboard. The head should be glued approximately ¾" (2cm) below the metal clip.

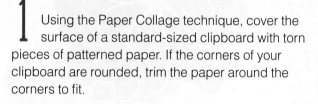

3 Using high-quality acrylic paint and a fine-tip paintbrush, paint the hair onto the figure with burnt umber. Let the paint dry. Highlight the hair with metallic gold paint. Use pink chalk and a cotton swab to highlight the cheeks on the figure's face.

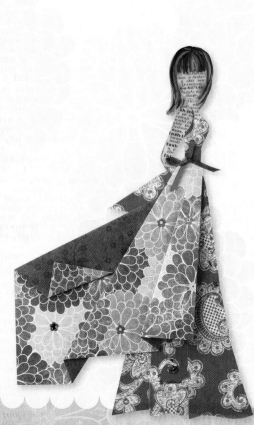

Tip

Before you fold the actual patterned paper for the train, try making a template on a piece of regular typing paper. I always need to practice my folds before I make them on the actual project.

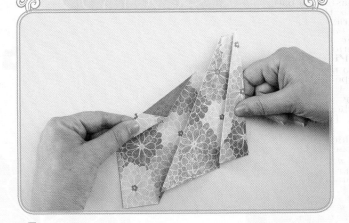

4 For the train of the dress, cut a 5¾" × 7½" (14.5cm × 19cm) piece of patterned paper. Determine the fold lines by placing a straightedge on the paper and scoring several lines at different angles with a craft knife. Use the picture as a guide. Fold the paper back and forth, accordian-style.

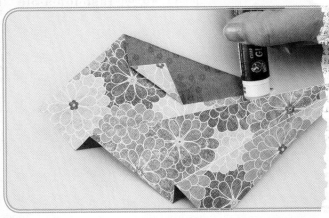

5 Glue the folds down at the top of the train, leaving the bottom open. Paper-clip the top together until the glue dries. Glue the entire train to the figure's dress with craft glue.

6 Stamp a quote stamp on the left side of the clipboard with brown ink. Squiggle over the stamp with pink glitter glue.

7 Glue a length of beaded ribbon beneath the metal clip, positioning it so the clip sits on top of the ribbon and the beads dangle beneath. Glue a ribbon to the waistband of the figure's dress and a self-adhesive rhinestone to the train of the dress. Thread 2 Asian-themed coins onto another length of ribbon. Glue one end of the ribbon beneath the metal clip. Adhere a silk flower to the top of the metal clip.

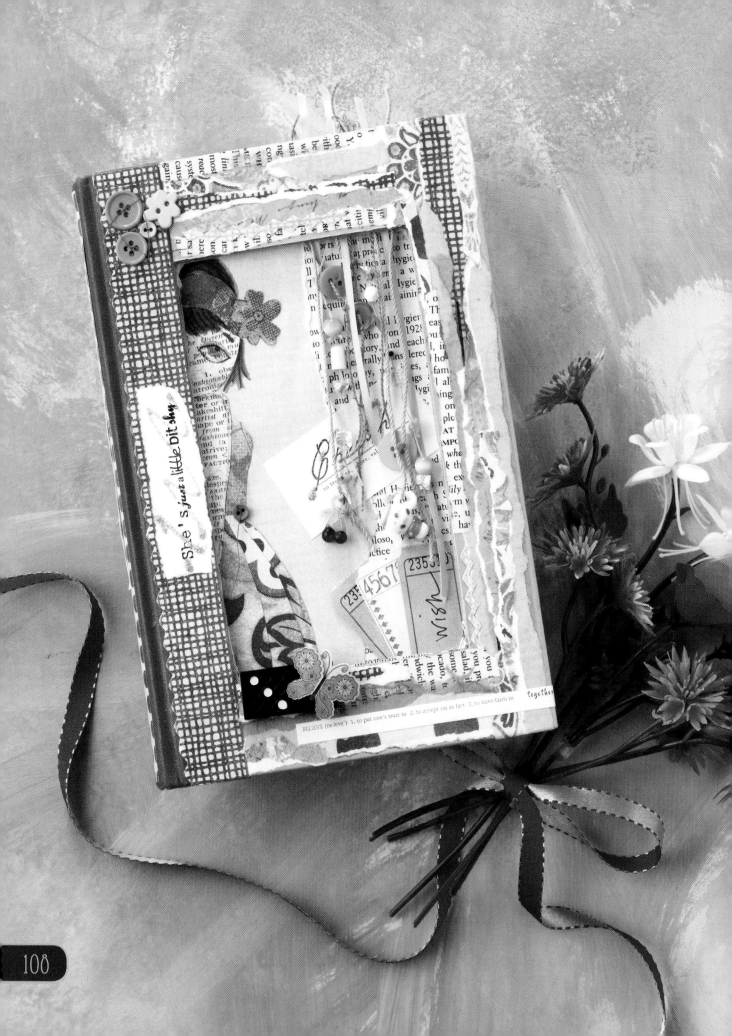

She's just a little bit shy

SHE'S JUST A LITTLE BIT SHY

We all have old books with stained covers or torn pages hiding in our closets or attics. I hate to throw them out, so I just create new ones! I simply embellished the cover of this book, but you can apply gesso or paint to the inside pages so you can journal inside. I like the way the cutout space looks like a window, so I made a curtain out of string and ribbon tied with lots of buttons and beads. Such fun!

MATERIALS

- assorted patterned paper
- beads
- black fine-tip permanent marker
- brown artist markers in various tones
- buttons
- colored pencils
- cream cardstock
- decoupage medium
- domino embellished with a butterfly
- old book
- pencil
- pink chalk
- pink glitter glue
- pink ink
- pink thread
- quote and text stickers
- ribbon, string and novelty yarn
- tickets
- tissue paper
- tracing paper

TOOLS

- cotton swab
- craft glue
- craft knife
- foam brush
- glue stick
- printer
- scissors
- scrap paper
- scroll stamp
- straightedge

TECHNIQUES

Sketching a Fashion Figure (page 10)

Facial Features and Hair (page 16)

Sketching Clothing (page 20)

Putting the Figure Together (page 28)

Paper Collage (page 30)

1 Using a craft knife and a straightedge, cut a rectangle from the cover of an old book. The rectangle should be about 1" (2.5cm) smaller than the cover on all sides. Cut through approximately ¼" (6mm) of the pages in the book as well. Set the book pages aside.

2 Stamp the edges of the pages with a scroll stamp and pink ink.

3 Cut a strip of patterned paper to fit over the spine. Brush a coat of decoupage medium onto the spine and let it dry; this makes the cover stickier for the paper. Decoupage the strip to the spine. Adhere a quote sticker, and then brush another coat of decoupage medium over the entire spine.

4 Lay a piece of scrap paper under the cover so the decoupage medium doesn't damage the pages. Decoupage a strip of patterned paper on the left side of the cover and strips of patterned paper, tissue paper and book pages onto the rest of the cover.

5 Print out the title, *She's Just a Little Bit Shy*, on a piece of cream cardstock and tear it out. Decoupage the title to the left side of the cover. Adhere a quote sticker to the bottom of the cover. Decoupage over the entire cover once more. Let the medium dry.

6 Tear a piece of patterned paper to cover half of the exposed page within the "window" of the cover. Glue the paper onto the page.

7 Sketch the head and the upper part of a dress, and trace them onto tracing paper. Use your sketch to cut out the figure using book pages; cut out the dress pieces from your choice of patterned paper. Glue the figure into place over the torn patterned paper. Using brown artist markers in various tones, draw in the figure's hair. Cut out a headband and glue it over the hair. Using a black fine-tip permanent marker and colored pencils, draw in the eyes and facial features. Use pink chalk and a cotton swab to highlight the cheeks on the figure's face.

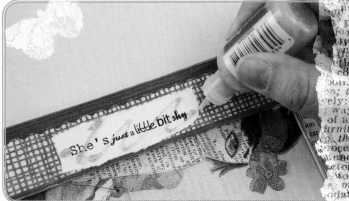

8 Embellish the page with a text sticker and tickets with the word *wish* written on them. Tie beads and buttons to strands of ribbon, string and novelty yarn. Glue the strands to the top of the second page in the book so the strings hang down like a curtain within the window. Glue the first page to the second page with a glue stick.

9 Thread buttons with pink thread and glue them to the cover and the figure's dress. Glue a small domino embellished with a butterfly to the cover. Embellish the title with pink glitter glue.

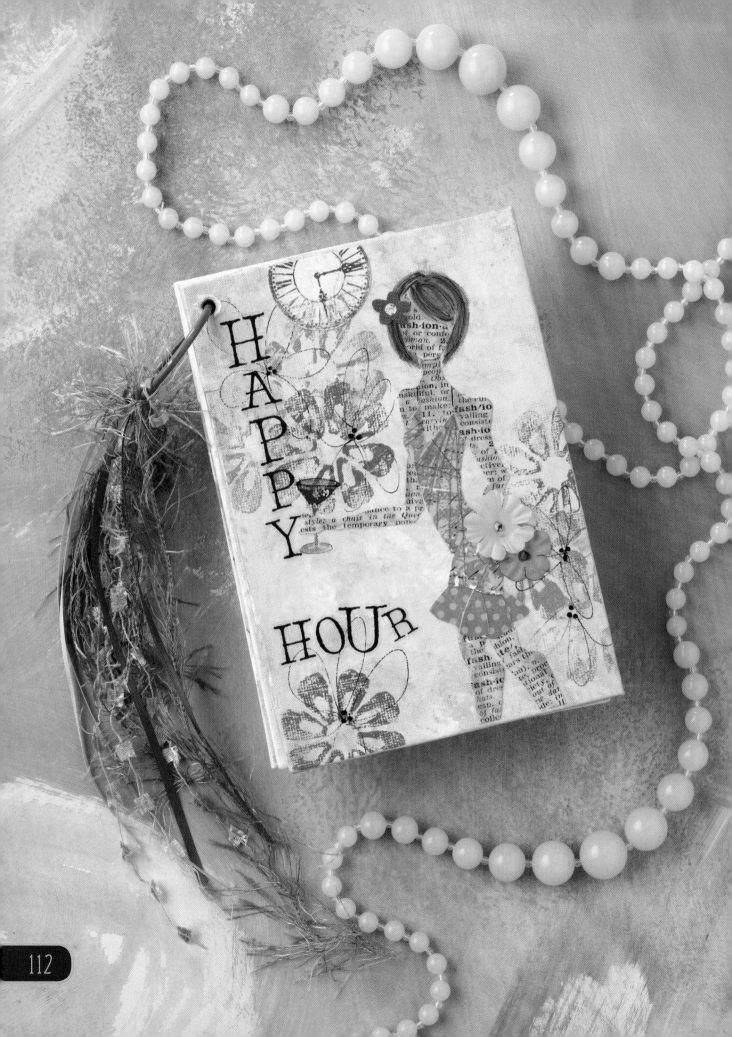

HAPPY HOUR

This project incorporates most of the background techniques found on pages 29–31. I came up with this project when I needed a gift for a twenty-one-year-old's birthday. I included it with a martini glass and shaker, and it made the cutest gift! This idea can easily accommodate cupcake or cookie recipes. The binder ring makes it easy to hang on a cabinet knob or a pot rack for all to admire.

MATERIALS

5" × 7" (12.5cm × 18cm) canvas boards

acrylic paints in desired colors

alphabet stickers

assorted patterned paper, including text-patterned paper

binder ring

black fine-tip permanent

black medium-tip permanent marker

cardstock in cream and blue

clock, flower, sun and seashell collage elements

colored markers

decoupage medium

high-quality acrylic paints in golden yellow and burnt sienna

pencil

pink chalk

ribbon and novelty yarn

self-adhesive rhinestones

silk flowers

tracing paper

TOOLS

cotton swab

craft glue

eyelet or grommet punch

fine-tip paintbrush

flower stamp

foam brush

natural sea sponge

printer

scissors

TECHNIQUES

Sketching a Fashion Figure (page 10)

Facial Features and Hair (page 16)

Sketching Clothing (page 20)

Folds and Ruffles (page 26)

Putting the Figure Together (page 28)

Sponging (page 29)

Stamping (page 29)

Paper Collage (page 30)

Bubble Wrap (page 30)

Brayer (page 31)

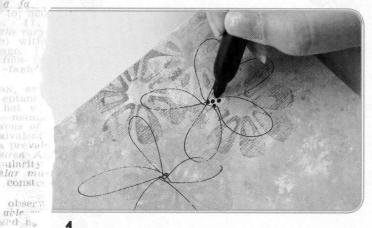

1 Paint both sides of three 5" × 7" (12.5cm × 18cm) canvas boards in different colors of acrylic paint. Punch a hole in the upper left corner of each board on the canvas side. Using the techniques from pages 29–31, embellish the boards. You can combine techniques on the same board, too.

For the cover, I used the Sponging and Stamping techniques. Draw flowers with a black fine-tip permanent marker. Dot the center of each flower 3 times with a medium-tip permanent marker.

2 Sketch a figure and her dress, and trace them onto tracing paper. Use your sketch to cut out the figure using text-patterned paper; cut out the dress using patterned paper of your choice. Decoupage the figure and dress onto the cover of the book.

3 Using a high-quality acrylic paint and a fine-tip paintbrush, paint the hair onto the figure with golden yellow. Let the paint dry. Highlight the hair with burnt sienna paint. Use pink chalk and a cotton swab to highlight the cheeks on the figure's face.

4 Decoupage a flower collage element in the figure's hair and a clock collage element at the top of the cover.

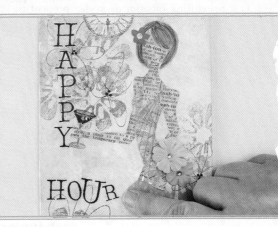

5 Draw a martini glass in the girl's hand with a black fine-tip permanent marker and color it in with a colored marker. Adhere a self-adhesive rhinestone to the glass. Draw thin lines for straps on the dress.

6 Glue silk flowers with rhinestone centers to the cover. Spell out *Happy Hour* with alphabet stickers on the left side of the board.

7 For an inside page, print a drink recipe onto cream cardstock. Draw flowers over the recipe with colored markers and then cut it out. Mount the recipe on a slightly larger piece of blue cardstock. Decoupage the recipe to the back of the cover.

8 Sketch a dress and trace it onto tracing paper. Use your sketch to cut out the dress using patterned paper of your choice. Decoupage the dress below the recipe.

9 Decoupage a sun collage element onto the top of the canvas board.

10 For another inside page, print out a drink recipe onto cream cardstock and then cut it out. Mount the recipe on a slightly larger piece of blue cardstock. Decoupage the recipe to the board.

11 Sketch a figure and a bikini. Instead of legs, draw a mermaid tail. Use your sketch to cut out the figure using text-patterned paper; cut out the bikini and tail using patterned paper of your choice. Decoupage the mermaid to the bottom of the board.

12 Using a high-quality acrylic paint and a fine-tip paintbrush, paint the hair onto the figure with burnt sienna. Let the paint dry. Highlight the hair with golden yellow paint. Use pink chalk and a cotton swab to highlight the cheeks on the figure's face. Decoupage seashell collage elements to the left of the mermaid and a flower collage element to the corner of the recipe.

Make as many pages as desired. Connect the book with a binder ring embellished with strands of ribbon and novelty yarn.

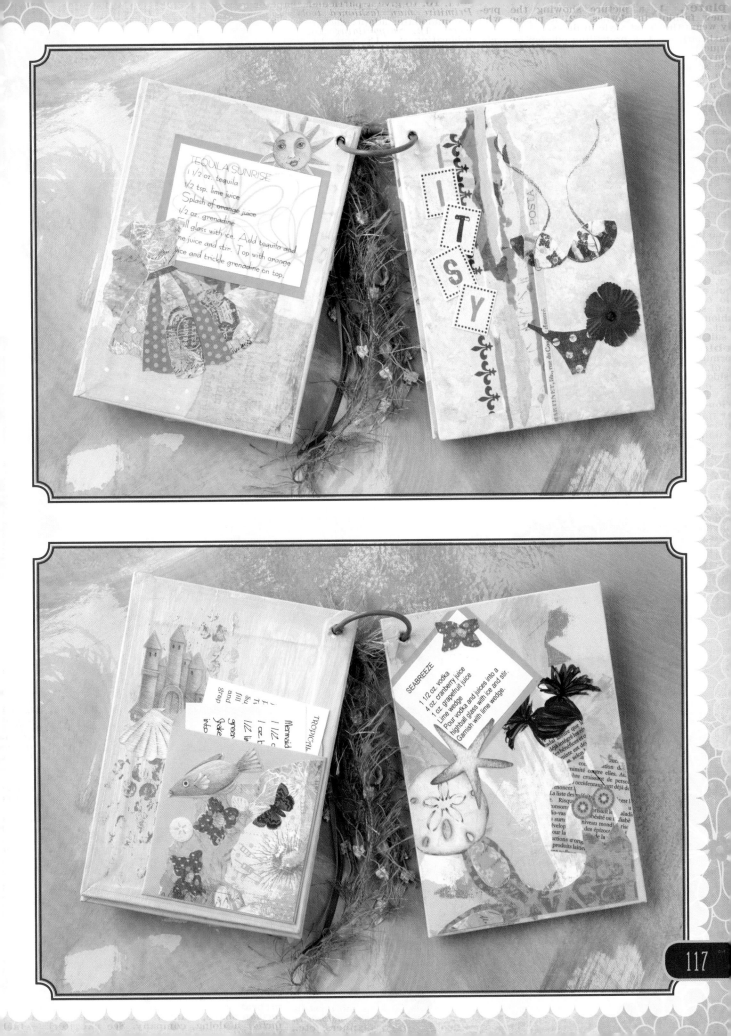

TEQUILA SUNRISE
1 1/2 oz. tequila
1/2 tsp. lime juice
Splash of orange juice
1/2 oz. grenadine
Fill glass with ice. Add tequila and
lime juice and stir. Top with orange
juice and trickle grenadine on top.

SEABREEZE
1 1/2 oz. vodka
4 oz. cranberry juice
1 oz. grapefruit juice
Lime wedge
Pour vodka and juices into a
highball glass with ice and stir.
Garnish with lime wedge.

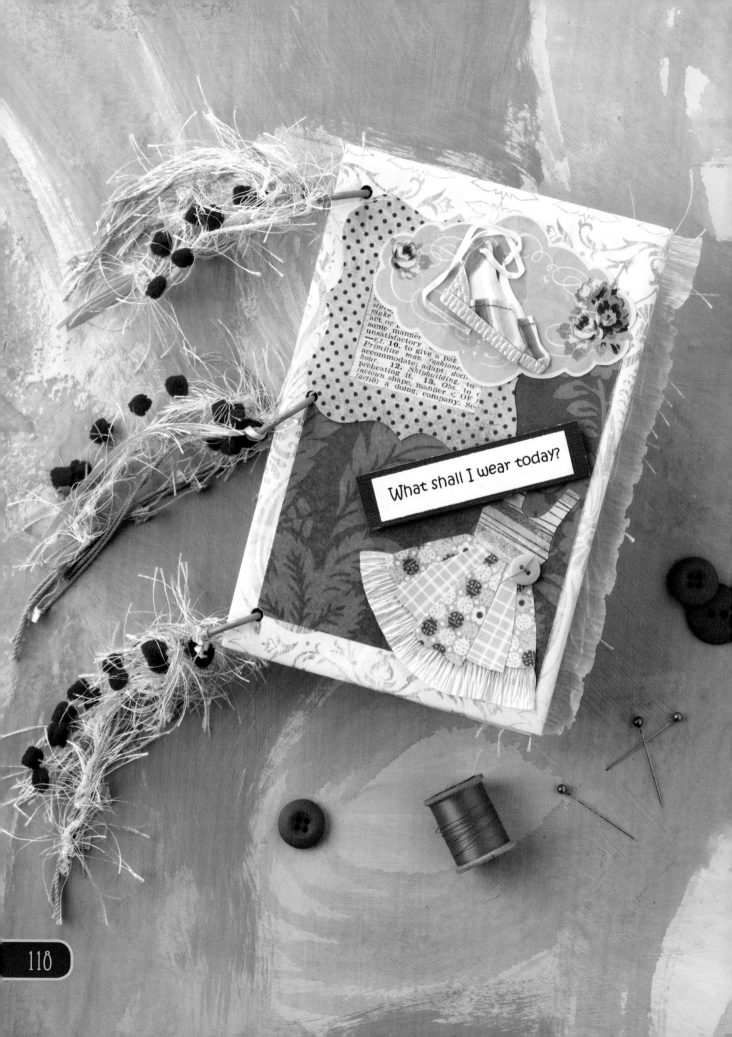

WHAT SHALL I WEAR?

This sweet book would make a perfect gift for any little girl. Personalize it by using a photo of the recipient instead of a paper head. Of course, using papers in her favorite colors is a must! You could even add must-have accessories such as hats and bags. A girl's never too young to learn the fashion basics!

MATERIALS

assorted patterned paper, including text-patterned paper and green patterned paper

black fine-tip permanent marker

black medium-tip permanent marker

brown artist markers in various tones

buttons

cardstock in cream, pink and white

chipboard book covers

colored markers

die-cut frame and tag

green crepe paper

heart-shaped brad

ink in black and green

novelty yarn

pencil

pink chalk

pink thread

plastic binder rings

scroll, shoe and butterfly collage elements

silk flowers

tracing paper

yarn, fiber, string and ribbon

TOOLS

3-D glue dots

cotton swab

craft knife

eyelet maker

gate stamp

glue stick

hole punch

large scroll stamp

printer

scissors

straightedge

text stamp

TECHNIQUES

Sketching a Fashion Figure (page 10)

Facial Features and Hair (page 16)

Sketching Clothing (page 20)

Folds and Ruffles (page 26)

Putting the Figure Together (page 28)

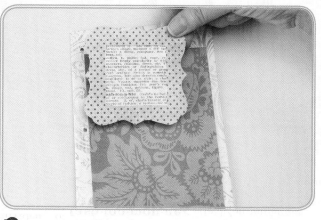

1 Using a glue stick, cover a chipboard book cover on both sides with patterned paper. Using an eyelet maker, make 3 holes evenly spaced along one long side of the board for the binder rings.

2 Cut a rectangle of contrasting patterned paper somewhat smaller than the cover and glue it in place. Glue a piece of text-patterned paper behind a die-cut frame. Glue the frame on the upper left side of the cover. If the frame covers the holes, repunch them with a hole punch.

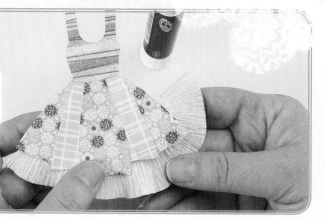

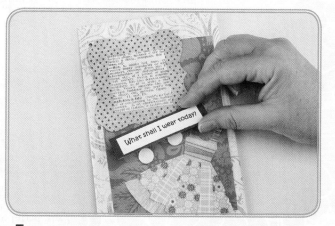

3 Sketch a dress and trace it onto tracing paper. Use your sketch to cut out the dress using patterned paper of your choice. Glue the dress pieces together. Cut a ¼" (6mm) wide piece of green crepe paper to fit along the bottom hem. Stretch the crepe paper on one long edge to make a ruffle. Glue the crepe paper to the bottom hem.

4 Print out the title of the book, *What Shall I Wear Today?*, on cream cardstock and cut it out. Cut a slightly larger piece of pink cardstock and glue the title to it. Glue the title to the book with 3-D glue dots just above the dress.

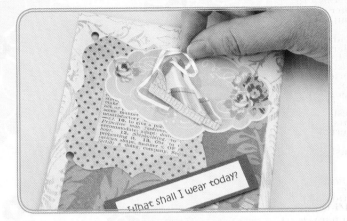

5 Glue a scroll collage element over the frame from Step 2. Glue on a shoe collage element. Thread a button with pink thread and glue it to the dress.

6 Use cream cardstock for all inside pages. Punch 3 holes, evenly spaced, along the left edges, using the cover as a guide. Stamp the first inside page with a large text stamp and black ink.

7 Sketch a girl's body and outfit, and trace them onto tracing paper. Use your sketch to cut out the figure using text-patterned paper; cut out the outfit using patterned paper of your choice. Glue the figure and the outfit to the center of the page.

8 Draw and color in the shoes on the figure with a black medium-tip permanent marker. To create highlights, leave small squiggles of the shoes uncolored.

9 Draw hair on the figure with brown artist markers in various tones. Use pink chalk and a cotton swab to highlight the cheeks on the figure's face.

10 Print a quote onto cream cardstock and cut it out. This quote says, "A new dress just makes everything better, doesn't it?" Cut a slightly larger strip of pink cardstock and glue the quote onto it. Glue the quote to the right side of the page.

11 Using colored markers, draw a balloon above the girl. Draw the string with a black fine-tip permanent marker.

12 On another inside page, stamp the background with a large scroll stamp and green ink. Cut a piece of green patterned paper smaller than the page for the back of the closet.

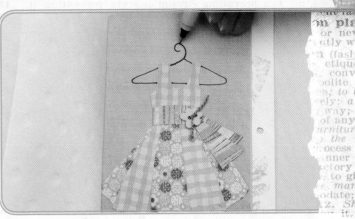

13 Cut another piece of paper for the closet door, ¼" (6mm) smaller on all sides than the back of the closet. Using a craft knife and a straightedge, score a line down one longer side, ¼" (6mm) from the edge. Glue the door into place along the scored side so it opens like a real door.

14 Sketch a dress and transfer it onto tracing paper. Use your sketch to cut out the dress using patterned paper of your choice. Assemble the dress with a glue stick, and then glue the dress inside the closet. Glue a button threaded with pink thread on the dress. Draw a wire hanger with a black fine-tip permanent marker.

15 Punch a hole in the top of a die-cut tag. Punch a corresponding hole in the top left corner of the door. Connect the tag to the door with a heart-shaped brad.

16 Glue a butterfly collage element above the door. Glue a button to the right side of the door for a doorknob.
Continue making inside pages as desired.

Tip

To make this project interactive, you could glue the girl forms onto the pages and add hook-and-loop dots to attach different outfits so the dolls can play dress up!

17 Repeat Step 1 to prepare a back cover for the book. Glue a square of patterned paper on the inside back cover (the holes should be on the left) toward the bottom. Stamp a gate image onto a piece of white cardstock and cut it in half. Score the left edge of the left piece and the right edge of the right piece, ¼" (6mm) from the edges. Glue the gate pieces to the square of patterned paper along the scored edges so they open up.

18 Print the phrase *The End* on a piece of cream cardstock and cut it out. Cut a slightly larger piece of pink cardstock and glue the text to it. Glue the text behind the stamped gate pieces.

19 Glue silk flowers and buttons above the gate. Add a 1½" (4cm) wide strip of crepe paper to the right edge of the inside back cover. Glue a strip of novelty yarn along the edge of the crepe paper.

20 Gather the finished pages and sandwich them between the front and back covers, lining up the punched holes. Connect the book with 3 plastic binder rings.

21 Tie strands of yarn, fiber, string and ribbon to each binder ring.

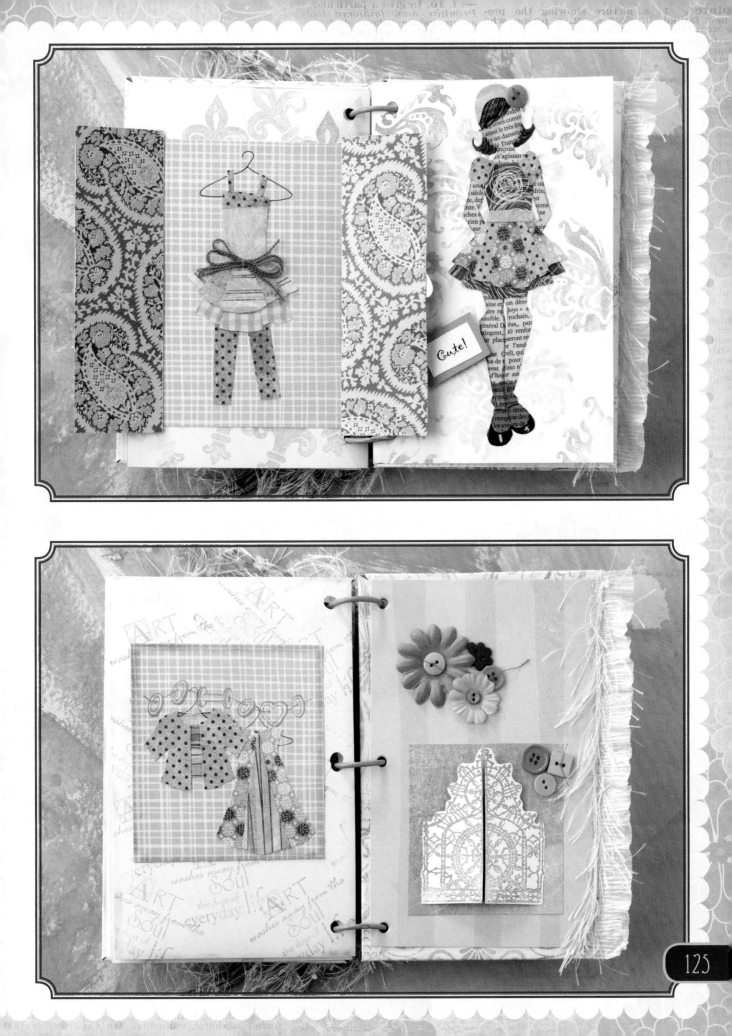

RESOURCES

Paper Lines I Use

Basic Grey
www.basicgrey.com
801.544.1116

Graphic45
www.g45papers.com
866.573.4806

K&Company
www.eksuccessbrands.com/kandcompany

My Mind's Eye
www.mymindseye.com
800.665.5116

Products I Recommend

Distress Ink by Ranger Industries
www.rangerink.com
732.389.3535

Glimmer Mist by Tattered Angels
www.mytatteredangels.com
970.622.9444

Mod Podge by Plaid
www.plaidonline.com
800.842.4197

Permanent markers by Sharpie
www.sharpie.com
800.346.3278

Scissors by Fiskars
www3.fiskars.com
866.348.5661

Stickles By Ranger Industries
www.rangerink.com
732.389.3535

INDEX

Backgrounds, 29–31, 43, 113–114
Book, 108–111
 gift, 118–125
 recipe, 113–117
Bookmark, 96–97
Brayer painting, 31, 64
Bubble wrap texture, 30, 44, 52, 56
Butterflies, 40–41, 108, 111, 123
Buttons, 45, 73, 95, 99, 108, 111

Canvas, 33
Children, 14–15
Clipboard, 104–107
Clothing, 20–23
 dancer, 74–75, 78
 denim, 46–49
 dresses, 20
 folds, 20, 23, 26–27, 37, 45, 49
 gowns, 22, 60–61, 104–107
 necklines, 20–21
 ruffles, 26–27, 53, 69, 72, 82, 90, 120
 shoes, 41, 45, 49
 skirts, 21
Color, 24–25, 38–41, 62–65
 background, 29
Corkboard, 67, 84–87
Credit card technique, 44
Croquis, 10, 23
Cupcake topper, 96, 98

Decoupage medium, 28
Denim, 46–49
Depth, creating, 29–31
Domino, 108, 111
Dresses, 20
 See also Clothing

Embellishments, 22, 52, 87, 91
 3-D, 103
 vintage, 89–91
 See also under specific embellishment
Embroidery floss, 61, 73
Eyes, 16–17, 19

Feathers, 77
Features, facial, 16–17, 19
Figure, 10–19
 assembling a, 28
 child, 14–15
 front-view, 10–11, 23
 mermaid, 116–117

posable, 74–78
proportions, 10–11, 14
skeleton, 62–65
three-quarter view, 12–13, 23
Flowers, 36-37, 47, 95
 die-cut, 49, 83, 86–87
 fabric, 103
 1970s-style, 46–48
 silk, 69, 83, 107, 115, 124
 stamped, 23, 36, 48, 57
 sticker, 65
 tissue paper, 64
 wooden, 73
 See also Roses
Foil cup, 72
Folds, clothing, 20, 23, 26–27, 37, 45, 49, 107
Frames, 67, 70–73, 75–81, 88–89, 91
 shadow box, 67, 74–78

Gowns, 22, 60–61, 104–107
Grid, drawing, 10–11

Hair, 18
 black, 18, 65
 blonde, 18, 61, 114
 brown, 18, 41, 45, 53, 57, 77, 99, 106, 116, 122
 red, 18
Heart punch, 38–39, 41
Hearts, 73, 80–82

Inspiration, 23, 33, 81
 Asia, 54–57
 color, 24–25
 Day of the Dead, 63
 food, 38
 France, 22, 50–53, 75–78, 84–87
 Mexico, 62–65
 newspaper, 58–61
 paper, 89

Journaling, 61, 82, 109
Journals, 100–103

Lips, 16–17, 19

Mood, getting in the
 beverages, 24, 35, 39, 47, 51, 63
 color, 25
 dress-up, 81

movie, 23
Movement, creating, 12–13

Necklines, 20–21
Newspapers, 40, 54–61
Noses, 16, 19

Paper, 24
 crepe, 69, 82, 120
 holiday, 94–95
 origami, 72
 patterns, choosing, 24, 26
 text-patterned, 42–44
 tissue, 26, 44, 60, 64
 See also Newspapers
Paper collage technique, 30, 44, 48, 52, 60, 64, 69, 102
Paper dolls, 98–99
Plaque, wooden, 68–69

Rhinestones, 77–78, 83, 107, 115
Ribbons, 69, 107, 111
Roses, 60, 64–65, 78, 82
Ruffles, 22, 26–27, 53, 69, 72, 82, 90, 120

Shadow box frames, 67, 74–78
Shoes, 41, 45, 49
Skirts, 21
Sponging, 29, 36, 40, 48, 52
Stamping, 22, 29, 40, 102
 flower, 23, 36, 48, 57
 potato, 55, 57
 See also Words, stamped
Stickers, 65, 115
Style, 22–23, 34–37, 46–49
 developing a, 10
 See also Inspiration

Tape, 59–61
Texture, 30, 43–44, 52, 56, 60

Words, 76, 86
 alphabet bead, 103
 chipboard, 87
 journaling, 61, 82
 quotes, 73, 82
 sticker, 115
 See also Newspapers
Words, stamped, 82, 121
 alphabet, 37, 52, 83, 87, 90
 French, 40, 83, 86, 99, 102

DISCOVER MORE WAYS TO COLLAGE IN STYLE
www.CreateMixedMedia.com

The online community for mixed-media artists

TECHNIQUES • PROJECTS • E-BOOKS • ARTIST PROFILES • BOOK REVIEWS

For inspiration delivered to your inbox and artists' giveaways,
sign up for our *free* e-mail newsletter.

COLLAGE PLAYGROUND
A Fresh Approach to Mixed-Media Art
Kimberly Santiago

Remember the carefree spirit you had as a child? It's time to recapture that sense of wonder and excitement in your art with *Collage Playground*! Come play with author Kimberly Santiago as she introduces you to 10 simple techniques and 25 projects that take the "work" out of collage and bring back the fun. As your imagination is reignited, you will discover textural ways to create with papers, fabrics, paints and more and learn tips for building up and using your own collage stash. Grab your pencil box and supply pail and join in on *Collage Playground*!

paperback; 8" × 10"; 144 pages
ISBN-10: 1-60061-793-X
ISBN-13: 978-1-60061-793-5
SRN: Z5252

COLLAGE FUSION
Vibrant Wood & Fabric Art Using Telamadera Techniques
Alma de la Melena Cox

Fuse vibrantly colored fabric and wood as you discover "telamedera," a new approach to collage. Wood becomes your canvas as you learn to use a wood-burning tool and mixed-media elements, including stencil-work, dimensional paint, fabric and personal imagery, to bring new art to life. Whether you're a quilter, painter, scrapbooker or completely new to the craft world, the ten projects and twenty techniques in *Collage Fusion* will ignite the fires of your own creativity.

paperback; 8.25" × 10.875"; 128 pages
ISBN-10: 1-60061-330-6
ISBN-13: 978-1-60061-330-2
SRN: Z2973

These and other fine North Light titles are available at your local craft retailer, bookstore or online supplier, or visit our website at www.ShopMixedMedia.com.

www.CreateMixedMedia.com
THE ONLINE COMMUNITY FOR MIXED-MEDIA ARTISTS